I Will Never Forget You . . .

Frida Kahlo to Nickolas Muray

Salomon Grimberg

I Will Never Forget You...

Frida Kahlo to Nickolas Muray
Unpublished Photographs and Letters

Tate Publishing

Contents

To Mimi

Acknowledgements

Nickolas Muray was "a man for all seasons." When he emigrated from his native Hungary to the United States, at twenty-one years of age, he brought with him the belief he would make an indelible contribution. At the time of his death, he seems to have photographed everyone and everything, from presidents to pea soup. Most Americans were familiar with his photographs, if not with their creator. Despite talent, personal charm, handsome looks, and boundless creative powers, he managed to live a self-effacing life. He was internationally renowned as a champion fencer; he was a pilot, and a lover of women. The most famous of his lovers was Mexican artist Frida Kahlo with whom he lived an affair that lasted some ten years. During that time, he photographed her more than any other person outside his immediate family.

In preparation for this book, I had the good fortune to receive the help of several persons, to whom I am deeply grateful.

Nick Muray's nieces Ilona Muray Kerman, Cornelia Muray Braun, and Violet Muray Tamas provided invaluable assistance in gathering information about the history of the Muray family. Were it not for their memories, Nick's history would have been lost forever. Karen and George Worth shared with me their recollections of Nick as a personal friend and as a fencer. For many days of patient hospitality, I am deeply indebted to Danny Jones, Nick's friend and colleague, who remained a sounding board during the development of this project. He supplied me with an intimate – and unique – understanding of Nick as a person and as an artist; Ginny and Frank Mc Laughlin opened my eyes to the way Nick looked and worked at the art of photography; I could not have wished for more sensitive and generous eye openers. For help with my research, I was fortunate to count on Dr. Andor Gellert, in Budapest, who helped me find Nickolas Muray's birth certificate and history about his religious background. Adriana Williams provided invaluable photos; Rosa Lozowsky in Mexico City helped me greatly at the Miguel Covarrubias Archives; Hayden Herrera in New York provided me with her notes on Nick's letters to Frida Kahlo; and Lynda Hofmann-Jeep, at Miami University, Oxford Ohio, helped me find information on the Hungarian community in New York at the time of Nick's arrival. Andy Shaw provided, generously, a most thorough documentation on Nick Muray's fencing history. Josep Bartolí and Ella Wolfe, who knew both Nick and Frida shared priceless memories.

The restored beauty of Nick Muray's glass plate color separation negatives is due to the artistry of Tod Gangler; Michael Bowers, Sal Lopes and Bruce Procter provided pristine prints of Nick's black and white negatives; and David Chasey brought to life Nick's Kodachrome transparencies as well as all the images used in the book.

I would like to thank the staff at the George Eastman House, who for the last thirty years has cared for the major collection of Nickolas Muray's work, nearly 25,000 prints, negatives and transparencies. I am particularly grateful to Dr. Anthony Bannon, Director of George Eastman House; Sean Corcoran, Assistant Curator of Photography; David Wooters, Archivist; Joseph R. Struble, Assistant Archivist; Rachel Stuhlman, Librarian; Wataru Okada, Registrar; and Barbara Galasso, photographer, for their patient assistance in researching materials and providing reproductions for this book.

I am indebted to Margaret Barlow, my editor, who dutifully – and carefully – read my manuscript and made it look the best it could. Barbara Hoffman Esq. and Lothar Schirmer were most helpful in making this project a beautiful reality.

Lastly, but particularly, I thank Mimi and Chris Muray for asking me to write this book about their father and trusting me with free access to the family archives. They could not have been more generous and helpful. Mimi not only provided the original idea, but also the soul of the project.

To each of you, thank you.

Salomon Grimberg

I Will Never Forget You ...

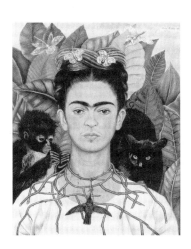

"Yes," Nickolas Muray replied to his adolescent daughter Mimi's question of whether he had loved many women prior to marrying her mother. "Many," he added, "but only one at a time." What he did not say – he was too discreet – and she would only discover many years after his death, is that there had been one woman he could not forget; he had loved her more deeply, more passionately, and more quietly than any of the others.[1] Her name was Frida Kahlo.

Mimi Muray grew up with Frida Kahlo's unavoidable presence in her home. Whenever she walked into the living area of the family apartment, Frida's *Self-Portrait with Thorn Necklace* was the dominating presence. Inspired by traditional paintings of the inwardly staring Christ Pantocrator, Kahlo had portrayed herself in front of a backdrop of plants with a black cat over her left shoulder and a spider monkey on the right one; deep into her tender flesh dug a necklace of thorny branches from which dangled a dead hummingbird. It was one disquieting presence that one could not avoid. Yet, Nickolas Muray treasured the painting and would never have dreamt of living without it. Nick had acquired it – fresh off the easel – directly from Frida Kahlo herself, in 1940, the year in which she and her husband, Mexican muralist Diego Rivera, divorced after ten years of marriage. Frida's behavior had led Nick to believe that he and Frida would marry as soon as the divorce was settled, but that had not been the case. Though Frida and Diego had been separated much of 1939, and despite the divorce, she remained attached to Diego and unwilling to let go. What Kahlo did not state in words, she conveyed in the self-portrait. It was plain to see that although she was there, she was absent too. Whatever the conflict was, Nick knew it was not he that was on her mind and began to withdraw.

Mimi had always known that Frida Kahlo was a Mexican painter and a friend of Daddy's. Used to seeing celebrities visit their home regularly, she did not consider the fact of what Frida might have meant to him. But by the time it dawned on her, she was no longer a child, and the players were no longer available to explain or to answer her questions. Yet, information, like unexplained messages, kept arriving in unexpected ways, as if some persistent force wanted her to know the story behind the many photographs of Frida by Nick that she kept finding. Her father was a man of few words, but these newly discovered photographs told a love story.[2]

Nickolas Muray was born on February 15, 1892 in Zseged, Hungary.[3] He was registered as Miklós Mandl, the fourth of five children, Artur, Vilmos, Margit, Miklós, and István, of Klára Lövit and Samu

Mimi Muray in her bedroom, N.Y.C., c. 1957. Photo: N. Muray

above: Frida Kahlo, *Self-Portrait with Thorn Necklace*, 1940. Photo: N. Muray. Col. Harry Ransom Humanities Research Center, University of Texas in Austin, USA

Mandl. Although his name appears in the Book of Birth Registration of the Jewish Community, he was not given a Jewish name. At the same time, the family, through the Ministry of Home Affairs, changed its surname to Murai, a non-Jewish name. Two years later, Samu, who worked as a postal employee, moved the family to Budapest in search of better educational and economic opportunities. His parents favored Miklós over the other children, as he was the most intelligent and unusually handsome, with an engaging

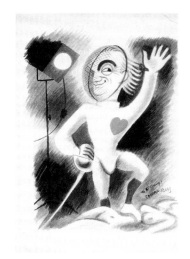

Miguel Covarrubias, *Caricature of Nickolas Muray as ›Lady Killer‹*, n.d.
National Potrait Gallery, Washington, D.C.
Gift of Mimi and Chris Muray

personality. Not only did he have a temper, but he was also strong-willed, rebellious, and unwilling to accept "no" for an answer. Repeatedly humiliated by rampant anti-Semitism, he resented being denied, for being Jewish, opportunities given other boys. His holding on to the memory of being belittled by a teacher would help him eventually find a way out of what he experienced as a dead end. Skipping school, in the afternoons young Miklós often walked by Santelli's fencing academy, peering in the window to watch the privileged ones who could afford to pay the ten *krönen* to attend – never had he earned more than five. These were ugly feelings he did not wish to have, so Miklós dreamt of being free to do as he wished, of being successful, of being surrounded by beauty. He promised himself not only that one day he would be able to afford fencing lessons but also travel and see "all the paintings in the world."[4] When he was twelve years old Miklós quarreled with his father over his truancy. Samu wanted him to become a lawyer, but his preferred son dug in his heels, refusing to attend the disliked teacher's class. As punishment, wanting to convey to him that he only was cut out to have a trade rather than to do intellectual work, Samu did – without realizing – what Miklós wanted when he apprenticed him to an artist's studio. Miklós loved it. He felt at home, learning wood engraving and

sculpture. And when he was ready, he entered the Budapest Graphic Arts School, where he avidly studied the fundamentals of photography, photoengraving and lithography. Upon graduation, he signed up with the photoengravers Weinwurm & Co., working one year as journeyman engraver doing lithographic reproduction. Miklós wanted to learn everything about his trade, and believing he had learned all he could in Hungary, he decided that Germany, where he would find the best craftsmen in the field, was the next step. At seventeen, eager to leave home, Miklós Murai moved to Munich for a year to study color separation. Next, in Berlin, he studied photochemistry, color photoengraving, and color filter making at the National Technical School. Earning the International Engravers Certificate would be his ticket to freedom; he could work with it anywhere in the world. Immediately after finishing his studies, Ullstein, the respected publisher, hired him exclusively to do photogravure.[5] Gradually, he shaped his dream into a reality. Miklós visited France and England, eagerly visiting museums. His earliest staged photographs of people in interiors date from this period. These works, strongly influenced by seventeenth-century Dutch painting, are particularly reminiscent of Rembrandt. He had no idea he was becoming a photographer.

Miklós had gone to Berlin to avoid mandatory military service in the Austro-Hungarian army. Fearing future repercussions, Samu reminded his son that he would not be able to return to Budapest without paying the consequences; but no amount of argument would change his mind. It had been like that since he was a boy. Furthermore, Miklós had no interest in returning to Hungary; he had other plans for the future. Sponsored by a cousin, his training complete, and having saved enough money for the trip, he left for America.

In August of 1913, armed with $25, a fifty-word English vocabulary, an Esperanto dictionary, and an unrelenting determination, twenty-one-year-old Miklós Murai arrived at Ellis Island, where he became Nickolas Muray. He immediately found work in Greenpoint, Brooklyn, at Stockinger Printing Co., doing engraving and color separation. He signed up for English night classes, eager to leave behind any trace of his accent, and he proclaimed himself an atheist. Knowing no one in New York would have made for a lonely time for most, but not for Nick, who had never known a stranger. Within the Hungarian community he found friends, and a wife in poet Ilona Fulop. Beautiful in a Romantic way, she was tall and slender, with large, deep-set brown eyes, and dark wavy hair. But marrying when boundless ambition to succeed keeps one away from home is a sure formula for failure.

Nickolas Muray in fencing costume, c. 1920. Photographer unknown

By 1920, after living in Chicago, where he worked as a union operator doing half tone printing and color photoengraving and fulfilled his dream of becoming a champion fencer, Nick returned to New York with the intention of doing portrait photography full time.[6] Before launching into such a venture, he called on his friend Pirie MacDonald, a fashionable men's photographer. After studying Nick's photographs, Pirie warned him that his work was too different, that the magazines wanted something more traditional and would likely reject it. Instead, he suggested, why not take a risk and open his own studio. Nick must have liked the challenge. No one to date who had warned him against doing something could say he had not done it — or that if he tried, he had failed. So he decided: he would open a studio first and find a way into the magazines later.

Divorced from Ilona, Nick moved to 129 MacDougal Street in Greenwich Village, where he lived in one room and worked in the other. Forced to economize at first, wondering when his next client would appear, Nick kept all the lights out, except for one bulb. When a client rang the doorbell, he would turn on all the lights, then off again when the client was gone. Fortunately, Nick did not have to wait long for his big break. Henry Sell, the editor and art director of *Harper's Bazaar*, saw a layout of Nick Muray's photographs in the *New York Tribune* and commissioned him to photograph Florence Reed, who was starring on Broadway in *The Mirage*. Overnight, his evocative, soft focus style of portrait photography became a sensation. He was soon photographing everybody that was anybody: actors, dancers, film stars, politicians, and writers. He also did commercial photography on a freelance basis: advertising, fashion, and interiors. Many of his sitters, drawn initially to Nick's high-quality photography, referred others or returned themselves because of his winning personality. He was dashing. Women were often enamored of him and men wanted to be his friend. As he grew more successful, he held Wednesday night soirees in studio for friends and acquaintances to meet, eat, and drink — many brought their flasks, as it was prohibition time. It was not unusual for Martha Graham, Langston Hughes, Helen Hayes, Paul Robeson, Gertrude Vanderbilt, Eugene O'Neill, or even Jean Cocteau to make an appearance. One never knew who would show up or how the evening would unfold. Someone might dance, another sing or play an instrument, or act their role in a current play. There might even be a fencing exhibition by members of the Washington Square Fencers Club. America agreed with Nick, and his life had turned around. It was fun.

The year 1921 was pivotal for Nick. One of the contracts came from Frank Crowninshield, who,

interested in all the arts, asked him to photograph celebrities for *Vanity Fair*. (Earlier, Nick had been color technician and engraver, doing color separation negatives for the magazine.) Through Crowninshield, Nick gained permission to photograph Helen Moeller and her students. Moeller taught the steps and movements created by Isadora Duncan, and like Duncan's 'Isadorables,' the students danced nude under translucent, gauzy togas. Overnight, the photograph of a dancer in a see-through toga, reproduced full page in *Vanity Fair,* gained him a reputation as the dance photographer. The project also introduced him to two Czechoslovakian sisters trained in classical ballet, Desha and Leja Gorska. The former was a radiant blonde with rosy ringlets, a sensuous body and exquisite skin, and a strong personality. Nick's friend Harriet W. Frishmuth used her as model for her sculpture *The Vine* (1921), today in the collection of the Metropolitan Museum of Art. (Nick also owned a copy.) Nick fell in love with Desha, but she knew her life as a ballerina was short, and she was not ready to cut it further by marrying.[7] Despondent over Desha's rejection, Nick allowed himself to be consoled in Leja's arms, and before long, they discovered she was pregnant. Responsible Nick did not need to think about it. He "did the right thing" and married Leja.[8] On August 11, 1922, Arija, their daughter – and the light of his eyes – was born. The tenderhearted Leja had fallen for Nick and wanted to stay married, but he was not in love with her, and an amicable divorce ensued.

Through Carl Van Vechten, writer for *The Globe,* in 1923, Nick met artist Miguel Covarrubias, whose friendship would change Nick's life.[9] At nineteen, already prodigious and brimming with talent, Miguel had recently arrived in New York City with a six-month stipend from the Mexican government. His caricatures were his entry ticket to

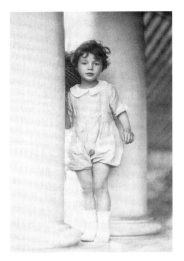

Arija Muray, c. 1923
Photo: N. Muray

the city's publications and art world and made him an overnight sensation. Van Vechten had recognized him as a budding genius and was quick to introduce him to influential people like Crowninshield, who, also impressed, offered him regular work. Miguel himself had also been a favored child and indomitable, skipping school to spend time in coffee houses and theaters were he drew caricatures of the patrons. At sixteen, he published his work and quickly earned the admiration of many artists such as Rufino Tamayo, Rodríguez Lozano, and Rivera. Initially, José Clemente Orozco influenced him, but Orozco was a bitter man and his caricatures were shaped by his bitterness. Miguel, who, like an endearing, mischievous child, found humor in the daily ironies, eventually shifted his interest and studied with Diego Rivera and Luis Hidalgo. Because Covarrubias was so much younger than the artists and other intellectuals with whom he associated, Hidalgo referred to him as "The Kid," and the nickname stuck with him all his life. Soon, Nick and Miguel were contributing to many of the same publications. During the next years the two moved in the same circles and became best friends.

In 1930, Miguel married Rosa Rolando, whom Nick had befriended a decade earlier while photographing the star (then named Rosemond Cowan) of the Fokine Ballet *The Rose Girl.* When Miguel and Rosa traveled to Mexico the following year, Nick met them there. He needed a vacation, having recently undergone an acrimonious divorce from Monica O'Shea, his third wife. Miguel's transparent passion for his extraordinary country had fascinated Nick, and he must have looked forward with eagerness to the time when they would visit Mexico together, so he could see it through his friend's eyes. Mexico, he knew, would be full of surprises; but he did not expect one of them to be Frida Kahlo.[10]

When Nick met Frida, in May of 1931, she had neither established the personality nor created the iconography for which she would be remembered. But she was on her way; Diego was carefully tending to the seeds of

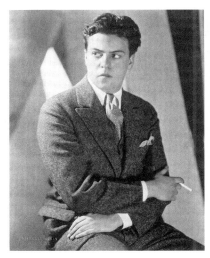

Miguel Covarrubias after his arrival in New York, c. 1923. Photo: N. Muray

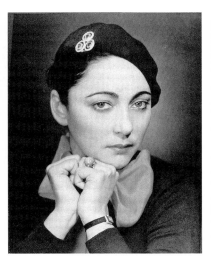

Rosa Covarrubias, n.d.
Photo: N. Muray

to appeal to her boyfriend Alejandro Gómez Arias: "I am beginning to grow accustomed to suffering,"[11] she wrote in one of her letters. The accident consolidated her use of illness as currency to draw attention. Alejandro was the leader

what she would become and paint. Frida Kahlo was born in Coyoacán, a small town in the outskirts of Mexico City. Her mother, Matilde Calderón had been a feisty *mestiza* and devout Catholic. During the Revolution, when the churches were closed, she secreted the local priest to her home to say mass, despite knowing the risk she was taking: death to all, no questions asked. Frida's father, Wilhelm Kahlo, had emigrated from Germany as a young man. His parents had been Hungarian Jews, but by the time he arrived in Mexico, he had decided never to return to Europe, and to become an atheist. Of his four daughters, Frida, his favorite one, was the most needy. As a child, she had trouble being alone, and she never overcame the problem. At six, during a bout with polio, she discovered that people did for the ill what they would not do for others: they paid special attention and spent more time with them. She never forgot the lesson. She was eighteen when a trolley car hit the bus in which she and her boyfriend were riding back from school. Her left shoulder was dislocated, her collar bone fractured, and her lumbar column broken in three places, as well as two ribs cracked, her right leg broken in eleven places, and her disjointed right foot crushed. Entering from the back, the steel handrail had impaled her abdomen emerging through her vagina.

Naturally, Frida's neediness was magnified, and in her letters, one can read how she used her illness

of a small group of students who stood out for their brains and their pranks, and Frida attached herself, feeling that her association with someone strong and influential would enhance her own power.

When Frida married Diego Rivera, who was old enough to be her father, he had lived in Europe some fourteen years and was the most powerful artist in Mexico. She became his third wife and clay in his hands, allowing herself to be molded to meet his needs. He encouraged and celebrated an attitude and behavior that stretched the limits of society's expected behavior. It was his idea for her to wear Tehuana costumes, to use the *retablo* format in her paintings, and to paint her life.[12] In one way, she became his best student; but in reality, it was her way to make herself more desirable and to keep a hold on him, a manner of relating she continued to develop. Shortly after their marriage, they traveled to Cuernavaca, where Diego had been commissioned to paint a mural in the Palace of Cortés with Ione Robinson as his assistant. Apparently, Diego and Ione had an affair during the time they worked on the mural, which might explain why the self-portrait Frida painted in Cuernavaca is the first where she appears with the characteristic, hard, self-absorbed look that would recur. Diego's philandering sparked her insecurity in the marriage. The following November, Frida and Diego left for San Francisco, where he was to complete commissions

at the San Francisco Stock Exchange Luncheon Club and the California School of Fine Arts. Six months later, in May of 1931, Frida returned to Mexico ahead of Diego, instead of with him, as planned, on the eighth of June.[13]

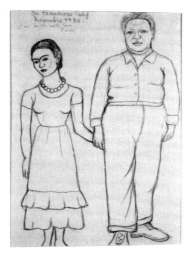

Frida Kahlo, *Frida and Diego*, 1930. Photo: N. Muray Col. Harry Ransom Humanities Research Center, University of Texas in Austin, USA

Nick and Frida's first meeting was certainly serendipitous as she was supposed to have been with Diego in San Francisco. Frida was surely riveted by Nick to impulsively allow herself a moment of passion with him, just days before Diego's return. She may have rationalized her behavior with the memory of Diego's recent affair with Ione. If he could do it, why couldn't she? There is not a single photograph that Nick took to record that trip, which is unusual, as he tended to carry at least his Leica and Rolleiflex cameras wherever he went, often snapping pictures as the day went on. It may be surmised from the two gifts Frida gave Nick, a drawing and a note, what was stirred within her during their moment together. The small drawing was one she had done the previous December in San Francisco, a self-portrait in which she holds hands with Diego. A fetus, hardly noticeable, is lightly drawn on her abdomen, over her dress. The drawing was probably the preliminary sketch for the marriage portrait she had finished just the previous month for the San Francisco art patron Albert Bender, shortly before returning to Mexico. The note was written on a paper doily, the kind used in restaurants, often placed on a dish under sweets.[14] The first paragraph is in a broken Hungarian, with spelling and grammatical errors; the second is in English, in which she was more fluent but still made frequent errors in spelling and grammar:

Nick,
I love you like I would love an angel
You are a Lillie of the valley my love.
I will never forget you, never, never.
You are my whole life
I hope you will never forget this

Frida —
May 31 1931.
Coyoacán.

Please come to Mexico as you
promised me! We will go together
to TEHUANTEPEC – in <u>August</u> –
This is specially for the back of your neck.
(Written below a lipstick print of a kiss)[15]

Side by side, the gifts provided Nick with a curious mixed message. Why give a lover a self-portrait holding hands with one's husband together with a promise of endless love? In retrospect, Frida appears to have been warning Nick that, although she will "never forget" him, she has no intention of separating from Diego either. For Nick, the gifts might have seemed just the memory of a moment shared, nothing else. Not so. Nick returned from Mexico with an admiration for all things Mexican, which came to mean amassing a collection of Mexican art, returning to Mexico often, and visiting Frida. The lovers' rendezvous in Tehuantepec did not take place as planned. Barely two months after Nick's departure, one month short of the planned trip, Diego was invited to present a show at the Museum of Modern Art in New York, so husband and wife left together for the United States.

Just before going to Mexico Nick had been in Europe buying color photography equipment. At the time, natural-color photography for advertisements was a source of heated debate in the United States. Many critics, and even photographers, believed it would never be good enough technically; others thought that when color was needed, an illustrator should paint the image. While they were

going about in circles, Nick had already decided to start working with color as soon as possible and had contacted European manufacturers about their new products. When Nick made up his mind to learn something new, he studied it thoroughly and from every possible angle, both positive and negative. Traveling extensively in Germany, he "lived" in photographic equipment factories. "I went all over Germany," he said, "to find the color processes they had. They had nothing to compare with the English Carbro process, but they had cameras."[16] He did not spare a cent, as he believed that the best equipment would provide the best possible outcome, and his equipment was far better than any of his American competitors'. He was especially proud of a particular purchase he made in Berlin, a *Jos-pe,* one-shot camera – a cumbersome, yet delicate camera holding three glass plates and filters with exposure through one lens – to capture exquisite color and fidelity of flesh tones. It was the first of its kind to reach America, and before sailing back to New York, Nick set the stage for success by contacting prospective clients about his find. When he stepped off the boat, he carried with him hundreds of dollars in color negatives to meet the orders cabled to him while overseas.

He had secured a contract with Curtis Publications to photograph fashions in color for the *Ladies' Home Journal,* so that when he left New York for Mexico in May 1931, the June issue containing his groundbreaking contribution was on the newsstands. Nick had pioneered the first illustration from a color photograph to be published in an American mass-circulation magazine, a swimming pool advertisement of seventeen live models wearing beach wear in Miami. Even charging $1,000 for a color page, he couldn't fill the incoming orders fast enough. Soon, he also had signed a contract with *Time* to do color covers for the magazine. The following year, when Edward Steichen, a friend and mentor of Nick's, gave a talk in the Art Directors Club of New York suggesting that the time for color photography was looming on the horizon, he

must have been thinking of Nick's recent work. Also in that year, 1932, Nick distinguished himself on another front as well when he participated in the Olympics after being U.S. Saber Champion in 1928 and 29.[17]

Frida visited New York with Diego twice, in 1931 and for Diego's show in 1933 for his mural commission in Rockefeller Center. Did Nick and Frida meet clandestinely during those times? In 1935, Frida returned to New York alone, during her first separation from Diego, after discovering his affair with her younger sister Cristina. Bertram Wolfe recalled how "she told her grief to my wife and me as her most intimate friends there, and vainly tried to get 'even' by having 'affairs' of her own."[18] Nick must have provided a warm shoulder to cry on; times were good to him. Henry Dreyfus had just been made art director of *McCall's*, and he had come up with the idea of a competition for photographers to see who would produce the best covers for the magazine. Each one in the selected group would receive $500, or $1,000 if the photo was accepted for publication. The magazine had three covers, the front and one each for the homemaking and food sections, and for the next ten years, each month, Nick "won" the competition to do at least two of the three.

At 13, Arija was a happy girl who adored her daddy; she was also the only person who dared stand up to him.[19] He was in awe of her self-assured personality, her common sense combined with a kind heart. A precocious child, she was an avid reader with definite opinions about the books she consumed, books like *Crime and Punishment* by Dostoyevsky, which by all accounts she could hardly put down, and another favorite, John Steinbeck's *The Grapes of Wrath*. She also wrote poetry, reflections on events that interested her, and fanciful stories like "The Adventures of an 1809 Nickel" or "The Strange Adventures of a Piece of Red Satin," written from the perspective of the coin and the fabric, respectively. The narratives were not only imaginative but also filled with insights. The reader learning

how the coin 'felt' as it was being shaped, which of its sides it liked best and why, its adventures as it changed hands, its joys, its suffering, its final destiny; or the satin's sorrowful existence beginning with its separation from a larger fragment of fabric, its disposal, and its discovery by a girl who makes a dress with it for her doll, then abandons both. To Nick's joy, Arija wanted to be an artist and study in Europe; she began making art early, studied drawing, watercolor, then oils. During the fall, Arija attended private schools, and she and Leja spent the summers in Ogunquit, Overbrook,[20] Poughkeepsie, or Wading River where Nick wrote, sent gifts, and sometimes visited – but not often enough as far as Arija was concerned. Nick was a strict disciplinarian – to him nothing was ever good enough – and quick to criticize even a small blunder, like a misspelled word, or his daughter's handwriting a letter when he told her he wanted her to practice typing. Arija, sure of herself, could hear what he had to say and take it in stride. But she would not be intimidated: "Did I really deserve the razzing you gave me on account of my 'few' little spelling mistakes? You can rest assured that I wont dare to make any more in this or future letters," and signed her letter with "Loads of Hugs and Kisses, and Love, from your big artist daughter, Arija."

Nick traveled to Mexico often, and Arija would write to him. She liked the gifts he always brought back for them. She was excited that, for her sixteenth birthday, she would be getting an easel from Miguel. In July of 1937, as construction and remodeling of his shop was making it impossible to work there, Nick left town for a time, going to Hollywood to photograph movie stars for magazine covers and then to Mexico, where he stayed with Miguel and Rosa in their Reforma home in Tizapán for a few days. Arija wrote: "I went up to

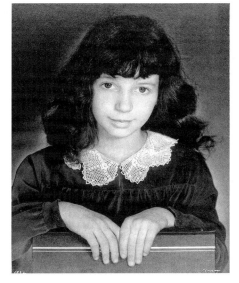

Arija Muray, c. 1933
Photo: N. Muray

the 'studio' today, or to what is left of it, and you can certainly thank your stars that you aren't there! Most of the walls have been torn down and cleared away, and the place is full of cement bags and the dust that they make. Poor Milly is constantly sneezing and coughing as she tries to hear voices over the telephone, above the noise of the workingmen. You are probably lying blissfully in that sun, baking into a deep golden-brown, or cramming hot chili peppers in your poor blistered stomach." On this trip, Nick used Kodachrome slide film, introduced in 1935, which was beginning to gain popularity. During a luncheon at the Covarrubias's, he photographed Frida – alone looking at him lovingly, with Diego holding hands, and touching Diego's lapel but looking directly at Nick while Miguel looks at her. He stayed in Mexico briefly before returning to New York for the grand party – with 300 guests – planned to celebrate the opening of his new studio.

In July of 1938, his stay was short as well. Frida was on the go much of the time, as André Breton and his wife Jacqueline Lamba were in Mexico for an extended period, which turned out to be three months, and the Riveras were showing them the sights, along with the Trotskys, their other guests. Nick photographed Miguel, Breton, the painter Roberto Montenegro, and Diego, looking at a pre-Hispanic object Diego is holding in his hands. On July 10, Arija wrote to Nick: "Gosh it was swell getting a letter from you at last! And hearing that you are coming up soon, was even better. Please come up as soon as possible, that is the 23rd of July. I am dying to hear all the thrilling tales of Mexico, and to see those swell presents you mentioned. Mother is so happy about your getting her that basket she wanted." What Arija did not suspect – could not imagine

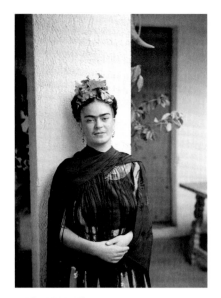

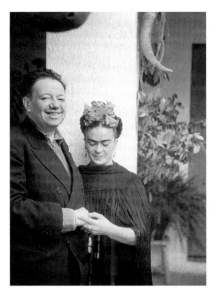

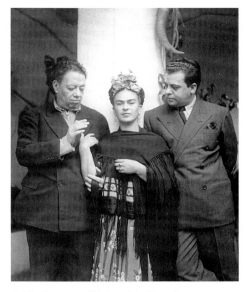

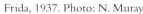

Frida, 1937. Photo: N. Muray

Frida and Diego, 1937. Photo: N. Muray

Frida, Diego, and Miguel in Tizapán, 1937. Photo: N. Muray

– was that one of the "swell" presents she was receiving from Nick for her sixteenth birthday was a car.

The Bretons departed on August 18, and Nick returned to Mexico sometime in September. He photographed Frida in color, wearing a white lace blouse through which one can see her hardened nipples. He also took some photographs of Frida wearing a pink and green satin blouse, surrounded by the organ cacti fence, in the front patio of the houses in San Angel Inn, her back to Diego's pink house. He took photos in the blue house on Allende Street where Diego and Frida are kissing, and some fun ones, such as one of Diego and Frida playing with a gas mask, Miguel with Frida, and a group picture (using a timer) that includes himself. If it is true that one picture tells a thousand words, a picture taken in San Angel Inn, tells the whole story. From left to right are the two sisters Alfa Ríos Henestrosa and Beta Ríos Pineda, Rosa Covarrubias, Nick, Diego, Miguel, Frida, and her Itzcuintli dog Kaganovich. In the version of the image published in the January 1939 issue of *Life,* the camera catches Frida in the precise moment when her face is turned toward Nick, giving him a loving side-look glance.

Frida's work is autobiographical. One painting she produced in 1938 appears to refer to their love

affair. It is a small work, barely 7 x 3.5 inches, which depicts a simple flower made up of two perfectly integrated parts: a red bell-like vagina and a penis received from above. The title of the painting, *Xóchitl,* is Náhuatl for "flower," but it also means "delicate thing," which is perhaps the reason why the painting is also known as *The Flower of Life.* The visual idea for the painting came to Frida from a glyph in the *Codex Mendoza,* for *Acaxochitla (aca,* reed; *xóchitl,* flower; and *tla,* abundance), which means, "Place abundant with flowers and reeds." In the *Codex,* the glyph is a single red flower penetrat-

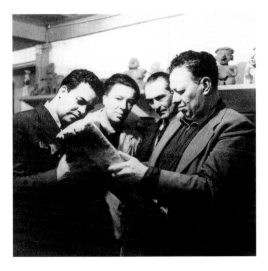

l.t.r.: Miguel, André Breton, artist Robert Montenegro, and Diego, looking at a pre-Hispanic object, 1938. Photo: N. Muray

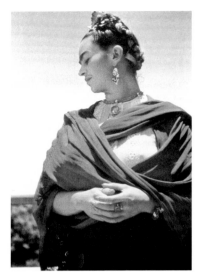

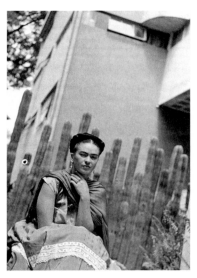

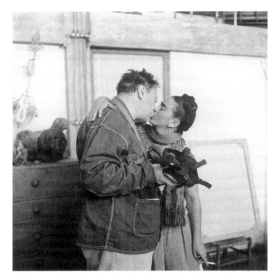

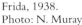
Frida, 1938.
Photo: N. Muray

Frida in the patio of the house in San
Angel Inn, 1938. Photo: N. Muray

Diego and Frida in Coyoacán, 1938
Photo: N. Muray

ed from above by a reed,[21] but the narrative behind the work comes from the Aztec myth about the origin of flowers. The story tells how a bat emerged from the semen of god Quetzalcóatl or Plumed Serpent, who took a piece from the genitals of Xóchitl, Goddess of Love, and out of this flowers were born.[22] In Mexico, '*coger flores*,' to pluck flowers, is the common term for deflowering. Privately, to Nick, Frida referred to herself as Xóchitl, even signed some of her letters to him that way. In a photograph of her bedroom, the painting hangs beside her bed.[23] Despite many previous love affairs, Nick had fallen for Frida's particular way of seducing, of drawing one in, of making one feel unique and special. Nick must have wanted to believe their affair held the promise of something permanent. They had developed an intense relationship, joking and laughing together, talking freely about anything and everything, including confiding in each other about the most intimate details of their passion. She enjoyed questioning him about his various escapades with other lovers, and he happily obliged. Her letters to him suggest she did not talk about her own adventures with other men; she held back that aspect of herself. But on most other topics, including her two overriding concerns, her illnesses and her troubles with Diego, she spoke freely. Nick surely knew that Diego, set

in his ways, was fairly difficult. Frida did not have to elaborate much. Miguel kept Nick informed of the gossip, and in one of his letters to Nick, giving news of Mexico, he simply reiterates that "Diego [is] more of a horse's ass than ever."[24] By the time Frida related her troubles with Diego to Nick, they were old news. In the back of his mind, Nick might have held out hope that sooner of later she would tire of his gratuitous cruelty to her and then be free to come to him. What he did not consider was Frida's masochism.

Julien Levy extended an invitation to Frida in early 1938 to do a show in his gallery of Surrealist art, which she accepted. The lovers must have thought it would be a perfect opportunity to spend time together. That September, in Mexico, she and

l.t.r.: Alfa Ríos Henestrosa and Beta Ríos Pineda, Rosa Covarrubias, Diego Rivera, Nick, Miguel Covarrubias, Frida Kahlo, and itzcuintli dog Kaganovich in San Angel Inn, 1938. Photo: N. Muray

Nick took care of practical preparations, like documenting the paintings, all in black and white, some in color, and separating works that would be shipped from those that she or Ella and Bertram Wolfe would carry. Frida eventually reworked some of the ones Nick photographed in color, like *A Few Small Nips*, *My Nurse and I*, and *Fulang Chang and I*, which had sustained an injury that left it with a large hole on the left side. Nick also printed photographs of several works in the exhibition for André Breton; for himself, he printed one, larger than life, of *Xóchitl*. Frida planned to leave for New York in early October, and the paintings needed to be shipped out ahead of her. Helping Frida arrange for her show prepared Nick for the work

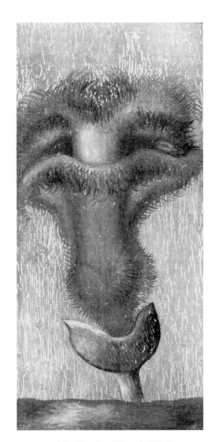

Frida Kahlo, *Xóchitl*, 1938.
Photo: N. Muray. Private Collection

he needed to do for his own forthcoming exhibition in London. In December, Nick was presenting a solo show of his recent work at the Royal Photographic Society of Great Britain. *Colour Prints by Nickolas Muray* included portraits of the actors Anna Mae Wong and Luise Rainer, and of His Eminence Cardinal Hayes. But the surprise of the show would be Nick's color commercial photography: "Color calls for a new way of looking at people, at things, *and* a new way of looking at color,"[25] he explained. In retrospect, many of these images would be forerunners of those that made Pop artists, like Andy Warhol, famous in the sixties. Advertisements of ads for orange juice, for tomato soup, cream of wheat, and Oldsmobile cars, were unusual themes at a photography exhibition in 1938. But Nick, master of the unusual, presented them as a new art form. Lenders ranged from Paramount Pictures and M.G.M. Productions to Mc Call Company, United Fruit Growers, and Cannon Towel. The Royal Photographic Society of Great Britain made him a fellow.

Astonished by Frida and her unique brand of Surrealism, Breton had also invited her to have an exhibition in Paris, to follow the one in New York. Diego encouraged her to attend each of the shows, reminding her to take advantage of opportunities that may not present themselves again, to enjoy the experience. He wrote letters of introduction to many persons who could be of help to her. But, Frida had unspoken misgivings about leaving Mexico. Had Diego been trustworthy, even reliable, she might have felt differently. Since the Diego-Cristina affair, their marriage had never quite reestablished the harmony – if that is what it could be called – it had had at one time. Frida's separation anxiety had received a jolt that made her hyper alert about the comings and goings of Diego. She was also furious, and did not pass up the perfect opportunity to get back at Diego by having an affair with Leon Trotsky, greatly admired by Diego, and their houseguest to boot.[26] Diego found out about it in due time, as well as about the affair with Nick, and he would have his day, also. Their dynamics dovetailed. Despite her apparent valorous stand, Frida was insecure about her ability to survive on her own; she clung to him, feigning submission, deluding herself that their freedom was comparable. Diego had the winning hand, as Frida Kahlo was enslaved to him by her fear of abandonment, and she knew it.

Frida's predicament was clear. Diego was right when he said that going to New York and to Paris would be good for her and her painting; it really was in her best professional interest. But she also knew that leaving Diego for months in Mexico was setting herself up for who knows what surprise. "[H]e is called amoral – and in reality – he has

nothing to do with those who go by the laws or norms of morality," she wrote about him in her "Portrait of Diego," for his retrospective exhibition in Bellas Artes in 1949.[27] She had learned her lesson in the worst of ways. He was neither trustworthy nor reliable. Torn, she also knew it would be a way to keep the peace. She had to take a chance.

The New York show was a success and Frida was eagerly sought out. She was wined and dined. Her insecurity about Diego expressed itself in nonchalant comments about being separated from him, leading separate lives, being free; she did it so often and ambiguously, it must have been apparent that things were not as simple as she wanted them to appear. Although Frida was not exclusively with Nick – she had her fling with Julien Levy – she spent more time with him than with others. Passionately in love, Nick was vulnerable as he had never been before. Essentially a private person, Nick introduced her to his small circle of those closest to him, Leja and Arija, Marion Meredith – who ran the Studio and was lab manager – whom he'd nicknamed Mam, and his partner Ruzzy Green. Frida visited with them often. She also became friends with Blanche Hays,[28] his friend from the days when he had his studio on MacDougal St., and Mary and Salomon Sklar.[29]

Until then, Nick had taken many photographs of Frida but none like the portraits for which he had become famous. One morning after breakfast, Nick took Frida to the studio with the intention of doing a formal portrait of her using the luminous Carbro technique. He knew his craft so well that one shot was usually enough. But Nick could not get enough of Frida. Enthralled with how she looked in her magenta *rebozo,* he took a close-up of her head covered with it, light appearing to glow from her face.[30] There are two variants of a pose in

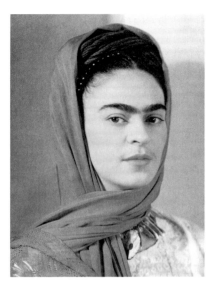

Frida Kahlo with Magenta *Rebozo*, 1939.
Photo: N. Muray

which she appears bathed in light from head to mid-skirt. In one a nimbus surrounds her: her back against the wall, her right hand rests over the left one, and her face turns to the left toward the viewer. Nick made a black and white print of it and sent it to Breton, who had requested it in Mexico. In the second, Frida is ravishing, her arms gently crossed, a slight smile, looking adoringly at Nick.[31] If her painting *Xóchitl* was Frida's acknowledgment of their mutual passion for each other, his portraits that morning were its echo. Twice Nick took Frida back to the studio to do other formal portraits of her before she sailed for Paris in January.

Paris Feb. 16 1939

My Adorable Nick. Mi Niño,

I am writting you in my bed in the American Hospital – yesterday it was the first day I didn't have fever and they aloud me to eat a little, so I feel better. Two weeks ago I was so ill that they brought me here in an ambulance because I couldn't even walk. You know that I don't know why or how I got colibacilus thru the intestines, and I had such an inflammation and pains that I thought I was going to die. They took several X rays of the kidneys and it seems that they are infected with those damn colibacilus. Now I am better and next Monday I will be out of this rotten hospital. I can't go to the hotel, because I would be all alone, so the wife of Marcel Duchamp invited me to stay with her for a week while I recover a little. Your telegram arrived this morning and I cried very much – of happiness, and because I miss you with all my heart and my blood… Your letter, my sweet, came yesterday, it is so beautiful, so tender, that I have no words to tell you what a joy it gave me. I adore you my love, believe me, like I never loved anyone – only Diego will be in my heart as close as you – always. I haven't tell Diego a word about all this troubles of being ill – because he will worry so much – and I think in a few days I will be all-

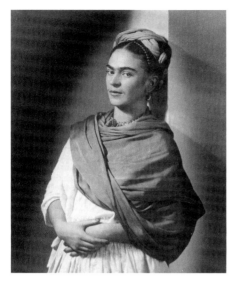
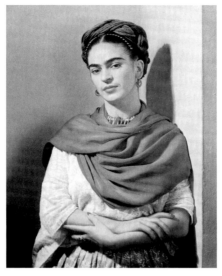
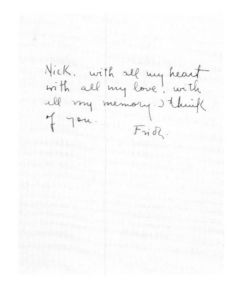

Variations of "Frida Kahlo with Magenta *Rebozo*", 1939. Photos: N. Muray Dedication on the backside

right again, so it isnt worthwhile to alarm him. Don't you think so?

Besides this damn sickness I had the lousiest luck since I arrived. In first place the question of the exibition is all a damn mess. Until I came the paintings were still in the custum house, because the s. of a b., of Breton didn't take the trouble to get them out. The photographs which you sent <u>ages ago</u>, <u>he never received</u> So he says — the gallery was not arranged for the exhibit <u>at all</u> and Breton has no gallery of his own long ago.[32] So I had to wait days and days just like an idiot till I met Marcel Duchamp (a marvelous painter) who is the only one who has his feet on the earth, among all these bunch of coocoo lunatic son of bitches of the surrealists. He immediately got my paintings out and tried to find a gallery. Finally there was a gallery called "Pierre Colle" which accepted the damn exhibition. Now, Breton wants to exibit together with my paintings 14 portraits of the XIX century (Mexicans) about 32 photographs of Alvarez Bravo,[33] and lots of popular objects which he bought on the markets of Mexico — <u>all this junk</u> [34], can you beat that? For the 15 of March the gallery supose to be ready. But the 14 oils of the XIX century must be <u>restored</u> and the damn restoration takes a whole month. I had to lend to Breton 200 bucks (Dlls) for the restoration because he doesn't have a penny. (I sent a cable to Diego telling him the situation and telling him that I lended to Breton that money — he was furious, but now is <u>done</u> and I have nothing to

do about it) I still have money to stay here till the beginning of March so I don't have to worry so much.

Well, after things were more or less settled as I told you, few days ago Breton told me that the asociated of Pierre Colle, an old bastard and son of a bitch saw my paintings and found that only <u>two</u> were possible to be shown because the rest are too "<u>shocking</u>" for the public!! I could of kill that guy and eat it afterwards, but I am so sick and tired of the <u>whole affair</u> that I decided to send everything to hell, and scram from this rotten Paris before I get nuts myself. You have no idea the kind of bitches these people are. They make me vomit. They are so damn "intellectual" and rotten that I can't stand them any more. It is realy too much for my character — I rather sit on the floor in the market of Toluca and sell tortillas than to have any thing to do with those "artistic" bitches of Paris.

They sit for hours on the "cafés" warming their precious behinds, and talk without stopping about "culture" "art" "revolution" and so on and so forth, thinking themselves the gods of the world, dreaming the most fantastic nonsenses, and poisoning the air with theories and theories that never come true. Next morning — they don't have anything to eat in their houses because <u>none of them</u> <u>work</u> and they live as parasites of the bunch of rich bitches who admire their "genius" of "artists". <u>Shit</u> and only <u>shit</u> is what they are. I never seen Diego or you, wasting their time on stupid gossip and "intellectual" discussions that is

why you are real <u>*men*</u> *and not lousy "artists" Gee weez! It was worthwhile to come here only to see why Europe is rottening. Why all these people — good for nothing — are the cause of all the Hitlers and Mussolinis. I bet you my life I will hate this place and its people as long as I live. There is something so false and unreal about them that they drive me nuts.*

I am just hoping to get well soon and scram from here.

My ticket will last for a long time but I already have acommodations for "Isle de France" on the 8 of March. I hope I can take this boat. In any case I won't stay here any longer than the 15th of March. To hell with the exhibition in London. To hell with every thing concerning Breton and all this lousy place. I want to go back <u>*to you*</u>*. I miss every movement of your being, your voice, your eyes, your hands, your beautiful mouth, your laugh so clear and honest.* <u>*YOU*</u>*. I love you my Nick. I am so happy to think I love you — to think you wait for me — you love me.*

My darling give many kisses to Mam on my name, I never forget her. Kiss also Aria and Lea. For you, my heart full of tenderness and caresses one special kiss on your neck.

> *your*
> *Xóchitl —*

Give my love to Mary Sklar if you see her and to Ruzzy

Paris. Feb. 27. 1939

My adorable Nick —

This morning after so many days of waiting — your letter arrived. I felt so happy that before starting to read it I began to wep. My child, I really shouldn't complain about any thing that happens to me in life, as long as you love me and I love you. It is so real and beautiful, that it makes me forget all pains and troubles, makes me forget even distance. Your words made me feel so close to you that I can feel near me your eyes — your hands — your lips. I can hear your voice and your laugh. That laugh so clean and honest that only <u>*you*</u> *have. I am just counting the days to go back. A month more! And we will be together again.*

Darling, I made a terrible mistake. I was sure your birthday was the 16th of January. If I knew it was the 16th

of February I would never send that cable that caused you unhappiness and trouble. Please forgive me.

Five days ago I left the hospital, I am feeling much better and I hope I will be entirely well in a few days. I couldn't go back to the damn hotel because I couldn't stay all alone. Mary Reynolds a marvelous American woman who lives with Marcel Duchamp invited me to stay at her house and I accepted gladly because she is really a nice person and doesn't have anything to do with the stinking "artists" of the group of Breton. She is very kind to me and takes care of me wonderfully. I feel rather weak after so many days of fever because the damn infection of collibacili makes you feel rotten. The doctor tells me I must of eaten something which wasn't well cleaned (salad or raw fruits) I bet you my boots that in Breton's house was where I got the lousy collibacili. You don't have any idea the dirt those people live in, and the kind of food they eat. Its something incredible. I never seen anything like it before in my damn life. For a reason that I ignore, the infection went from the intestines to the bladder, and the kidneys, so for two days I couldn't make pipi and I felt like I were going to explode any minute. Fortunately every thing <u>*its ok now*</u>*; and the only thing I must do is to rest and to have a special diet. I am sending you here some of the reports from the hospital. I want you to be so sweet to give them to Mary Sklar and she will show them to David Glusker,[35] so he can have an idea of what is the matter and send me indications of what I should eat. (Tell her please that for the three last days the urine tests shown that it is acid and before it was alkaline. The fever disappeared completely. I still have pain when I make pipi and a slight inflammation on the bladder, I feel tired all the time (specially on the back). Thank you my love, for making me this favor, and tell Mary that I miss her a lot and that I love her.*

The question of the exhibition finally its settled. Marcel Duchamp has helped me a lot and he is the only one among this rotten people who is a real guy. The show will open the <u>*10th of March*</u> *in a gallery called "Pierre Colle" They say its one of the best here. That guy Colle is the dealer of Dalí and some other big shots of the surrealism. It will last two weeks — but I already made arrangements to take out my paintings the 23rd in order*

to have time to packed them — and take them with me on the 25th. The catalogues are already in the printing shop, so it seems like everything is going on alright. I wanted to leave on the "Isle de France" the 8th of march, but I cable Diego and he wants me to wait till my things are shown because he doesn't trust any of this guys to ship them back. He is right in a way because after all I came here only for the damn exhibition and it would be stupid to leave two days before it opens. Don't you think so? In any case, I don't care if the show will be a successful one or not. I am sick and tired of the whole affair here in Paris, and I decided that the same thing would be in London. So I am not going to make any exibit in London.[36] People in general are scared to death of the war and all the exibitions have been a failure, because the rich bitches don't want to buy anything. So what is the use of making any effort to go to London to waste time only?

My darling, I must tell you, that you are a bad boy. Why did you send me that check of 400 bucks? Your friend "Smith" is an imaginary one — very sweet indeed, but tell him, that I will keep his check untouched untill I come back to New York, and there we will talk things over. My Nick you are the sweetest person I ever known. But listen darling, I don't realy need that money now. I got some from Mexico, and I am a real rich bitch, you know? I have enough to stay here a month more. I have my return ticket. Every thing is under controll, so realy, my love, it is not fair that you should spend anything extra. You have planty of troubles already to cause you a new one I have money even to go to the "thieves market" and buy lots of junk which is one of the things I like the best. I don't have to buy dresses or stuff like that because being a "tehuana" I don't even wear pants, nor stockings either. The only things I bought here were two old fashion dolls, very beautiful ones. One is blond with blue eyes, the most wonderful eyes you can imagine. She is dressed as a bride. Her dress was full of dust and dirt, but I washed it and now it looks much better. Her head is not very well adjusted to her body because the elastic which holds it, is already very old, but you and me will fix it in New York. The other one is less beautiful, but very charming. Has blond hair and very black eyes, I haven't wash her dress yet and is dirty as hell. She only have one shoe. The other

one she lost it in the market. Both are lovely, even with their heads a little bit loose. Perhaps that it is what gives them so much tenderness and charm. For years I wanted to have a doll like that because somebody broke one that I had when I was a child, and I couldn't find it again. So I am very happy having two now. I have a little bed in Mexico, which will be marvelous for the biger one. Think of two nice Hungarian names to baptize them. The two of them cost me about two dollars and a half. So you can see my darling, that my expenses are not very important. I don't have to pay hotel because Mary Reynolds doesn't alow me to go back to the Hotel all by myself. The hospital is already payed. So I don't think I will need very much money to live here. Any way, you cannot imagine how much I appreciate your desire of helping me. I have not words to tell you what joy it gives me to think that you were willing to make me happy and to know how good hearted and adorable you are. — My lover, my sweetheart, mi Nick — mi vida — mi niño, te adoro.

I got thiner with the illness, so when I will be with you, you will only blow, and...up she goes! The five floors of the La Salle Hotel. Listen Kid, do you touch every day the fire "whachumaycallit" which hangs on the corridor of our staircase? Don't forget to do it everyday. Don't forget either to sleep on your tiny little cushion, because I love it. Don't kiss any body else while reading the signs and names on the streets. Don't take any body else for a ride to our Central Park. It belongs only to Nick and Xóchitl — don't kiss any body on the couch in your office. Only Blanche Heys can give you massage on the back of your neck. You can only kiss as much as you want, Mam. Don't make love with any body if you can help it. Only if you find a real F.W. But don't love her. Play with your electric train once in a while if you don't come home very tired. How is Joe Jinks.[37] How is the man who massages you twice a week? I hate him a little, because he took you away from me many hours. Have you fence a lot? How is Georgie?[38]

Why do you say that your tripp to Hollywood was only half successful? Tell me all about it. My darling, don't work so hard if you can help it. Because you get tired on your neck and on your back. Tell Mam to take care of yourself, and to make you rest when you feel tired. Tell her

that I am much more in love with you, that you are my darling and my lover; and that while I am away she must love you more than ever to make you happy.

Does your neck bothers you very much? I am sending you here millions of kisses for your beautiful neck to make it feel better. All my tenderness and all my caresses to your body, from your head to your feet. Every inch I kiss from the distance.

Play very often Maxine Sullivan's disc on the gramophone.[39] I will be <u>there</u> <u>with you</u> listening to her voice. I can see you lying on the blue couch, with your white cape, I see you shooting at the sculpture near the fireplace. I see clearly, the spring jumping on the air, and I can hear your laugh – just like a child's laugh, when you got it right. Oh my darling Nick, I adore you so much. I need you so, that my heart hurts.

I imagine Blanche will be here the first week of March. I will be so happy to see her because she is a real person, sweet and sincere, and she is to me like a part of yourself.

How are Aria and Lea? Please give my love to them. Also give my love, to the Kid Ruzzie tell him that he is a swell guy.

My darling, do you need anything from Paris? Please tell me, I will be so happy to get you anything you may need.

If Eugenia phones you, please tell her that I lost her adress and that is why I didnt write. How is that wench?

If you see Rosemary give her lots of kisses. She is ok. To Mary Sklar lots of love. I miss her very much.

To you, my loveliest Nick, all my heart, blood and all my being. I adore you.

Frida
The photographs you sent finally arrived.[40]

On March 17, 1939, one week prior to Frida's return to New York, she re-presented to Ella and Bertram Wolfe a slightly different view of how she felt about Nick:

… Soon we will talk about everything at length. Meanwhile I want to tell you: that I have missed you very much – that I love you more and more – that I have behaved myself well – that I have not had adventures nor lovers, nor anything of the kind, that I miss Mexico more than ever – that I adore Diego more than my own life – that once in awhile I also miss Nick a lot, that I am becoming a serious person, and that to sum up, until I see you again I want to send you both lots of kisses.[41] Divide some of them equitably among Jay, Mack, Sheila and all the cuates. And if you have a small moment see Nick and give him a little kiss also and another for Mary Sklar.

Your chicua who never forgets you
Frida

Frida had been pulling at Nick's heartstrings. Bertram Wolfe's explanation of her multiple affairs was hard to dispute: "Frida was not falling in love again and again, but her affairs were always brief and never deep, and none of the men she carried on flirtations meant to her what Diego did. Since the trip to Mexico City from San Angel is long, and a ride in the city to my house short, they always offered me a ride, and, particularly, Frida, told me details of her current affairs."[42]

For the $400 Nick sent Frida to pay for expenses in Paris, when she returned to New York, he received her painting *What The Water Gave Me*, which she signed then and dated 1939, although it had been completed the previous year. It is Frida's metaphorical self-portrait of what life has given her. One does not see her face, only events of her chaotic life floating in the bathtub while she is bathing. The viewer sees, as if through her eyes, the events that rule her internal life, shown above her legs and feet as she sits in the bathtub. Breton had been riveted by the painting when he saw it on her easel in Mexico, and reproduced it in *Minotaure*, the French surrealist publication, and to accompany his essay on Frida, in his book *Surrealism and Painting*. It is likely that she had chosen it for Nick, as it was the best painting she had exhibited, and the most complex. It was also the most telling: it informed him that her life was shaped by destruction, another warning. That may have been the easiest part of their rapprochement. The difficult part – for Frida

– was her discovery that Nick was seeing other women. Although she had encouraged him repeatedly about going out with other "wenches," when she arrived and saw he was doing just that, she could not face it, and left impulsively in late April. It must have been difficult for Nick to understand the predicament she had put him in. On one hand she wanted him to be with other women; on the other, she wanted him to remain faithful. How could he win, if whatever choice he made was wrong? Frida never had any intention of leaving Diego, and there was only so far that she would go with Nick. As wonderful as their passionate exchange had been, she knew it was just an infatuation, something temporary. Although Nick had been deeply in love and regretted wounding her, he was not a fool. It was only a matter of time before Nick, who prided himself on his clear thinking, began to unravel the workings of his relationship with Frida.

Nearly one month following her hasty departure from New York, on May 16, 1939, Nick mailed two letters written on the same day, in care of Cristina, where Frida received correspondence from her lovers – just to be safe, to avoid complications with Diego should he came upon them. Opening his heart, Nick wrote that he had given all of himself to the one half of her she would give to him and held no grudges. On the contrary, he was appreciative and grateful of the experience, which still amazed him. It had become impossible to continue denying that what Frida really wanted was to be in Mexico with Diego. Nick had wanted for things to be different, but knew they could only be as they were. The second letter is his response to a call from her earlier that day with the news that Diego had asked her for a divorce. Nick had already heard this from Miguel.

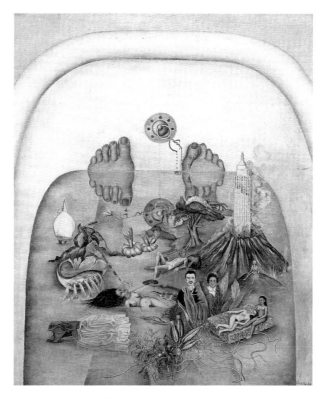

Frida Kahlo, *What the Water Gave Me*, 1938
Photo: N. Muray. Col. Isidore Ducasse Fine Arts, N.Y.

Sunday

Dear Dear Frida

I should have written long ago. It is a difficult world you and I live in.

It has been pretty desperate for you but no less for me when I left you in N.Y. and I heard from Ella Paresce everything about your departure.

I was not shocked or angry I knew how unhappy you were, how much you needed your familiar surroundings, your friends, Diego, your own home and habits.

I know New York only filled the bill as a temporary substitute and you found your haven intact on your return. Of the three of us there were only two of you I always felt that. Your tears told me that when you heard his voice. The one of me is eternally grateful for the happiness that the half of you so generously gave. My Dearest Frida – like you I've been starved for true affection. When you left I knew it was all over. Your instinct guided you wisely. You have done the only logical thing, for I could not transplant Mexico to New York for you and I've learned how essential that was for your happiness.

I wish I'd been born in your country with all its beauty and disadvantages. I'd be there now were I not part of a community made up mostly of worms and ants with their feet stuck in the mud, their hands tied and their souls in eternal chase of

cheap dollars. The only thing we have is a high standard of living and we pay for this with work till we die.

Frida – we cannot live without love or affection. I have looked for it – I am not quite sure that I've found it. I must tell you this, for I cannot, I don't think I could hide it from you. I am not psychic or can foretell the future; tomorrow is as mysterious to me as next year. My affection for you curiously enough has not changed, nor ever will. I hope you'll understand that, I should like a chance to prove that. Your painting is a joy to me. Very soon I shall mail you your color portrait I promised you. It is on exhibition in [the] Los Angeles Art Center. I want to know everything you want me to know.

Affectionately,

Nick

P.S. Will write you tonight if I can get away from this hellhole of my shop. We are working full steam…I find a great comfort [working] under duress. I'll talk with you with my pencil even if it will be short.

Love,

Nick

Dearest Frida

Your voice this morning told me nearly everything that happened to you. Also Miguel's letter brought me news and before that Carmen gave me your messages all about your difficulties your illness. You made me feel much like a dog for not writing you sooner. Even if the news was not happy for you. At least you should have heard from me. You must have been pretty desperate that you reached for me and it may sound paradoxical, your call made me happy because you must have thought that at least Nick will help you. If it is in my power to do anything Frida, it's yours, you, you must not have any doubts of that. It's incredible to believe that such friends as R [osa Covarrubias] would become as low as she has and upset, for selfish reasons probably a life long lie.[43] I've known others examples in her life that [she] is a pretty cheap gossip. Darling you must pull yourself together and lift yourself by your own bootstraps. You have at your fingertips a gift that love God or gossip cannot take away from you. You must work work paint paint paint work work. You must believe in yourself and in your own power. I also want you

to believe that I will be your friend no matter what happens to you or me. You must know I mean this. I am self-conscious writing to you of love and heart, because; because I am not sure if you won't misconstrue what I say. But I'll try anyway. I wrote you in my other letter, you or I or anyone who have human feeling, craves affection and something to love.

I was pretty sure, the difficulties of seeing the one I care for – will be practically impossible – for long periods of time.

I think you'll understand the rest without going into detail.

But this is what I want you to understand and remember! Caring for you will never end. It can't! I just as well get rid of my right arm my – or my brain. You understand don't you? Frida you are a great person, a great painter. I know you'll live up to this. I also know I've hurt you. I will try to heal this hurt with a friendship that I hope will be as important to you as yours to me is.

Your Nick

Beside the affair with Frida, which had left him aggrieved, despite believing that it was the logical denouement, Nick had other more immediate worries. Arija's long awaited trip to Europe to study painting was at hand, and it could not have come at a worse time. Nick was uneasy about the threat of war, but he agreed to let her and Leja travel to France, promising to catch up on Pan American's transatlantic clipper plane, which had enthralled him since its appearance four years earlier and was scheduled to begin flying passengers that coming July. Arija and Leja left New York harbor on the liner *Norddeutscher Lloyd Bremen* in late May and arrived in early June at the port of Cherbourg, where they boarded the train to Paris. From the ship, Arija wrote on June 6, the first of the "illuminated manuscripts" that Nick was expecting, informative letters complemented by her carefully drawn illustrations. Leja's sister Desha and their brother Jean picked them up in Paris at the Gare St. Lazare and took them to the Hôtel Celtic at 15 rue

D'Odessa, which Nick had recommended as it was near André L'hote's studio, where they signed up right away. Arija had visited France as a child, but now, as a young woman, almost seventeen, it was altogether different. She loved Paris, their hotel, the city, the food, the people, and she was happy meeting the family and friends again. They visited the countryside often, as well as museums and exhibitions; they went to the Can Can, to the Casino de Paris where they enjoyed Maurice Chevalier's performance and Desha's dancing act. Arija had her hair done, drank wine and met old friends of Nick and Leja. In their honor, Desha and Jean gave a cocktail party for about twenty-five people, with sandwiches, champagne, "and raw cauliflower dipped into a special Mexican hot sauce that was delicious," wrote Arija to Nick. Anna Duncan – Nick had made a film of her dancing – was at the party. Arija relayed to Nick that "we had lunch with her in the afternoon. She was delighted with the silk stockings, said they were the one thing she always wanted and needed, especially the good American ones. She is awfully sweet, hasn't changed much, she is still as poor as ever, poor thing. She teaches a few private pupils, not at Lisa Duncan's, but they don't bring in much. She mentioned how sweet it was of you to send that little Christmas gift it came at just the right time, when she was completely broke."

About school, Arija wrote in a letter dated June 12, 1939, that L'hote's school of painting "is a fair sized studio, just made of boards, and probably old as the hills, and crude and rickety, but it serves the purpose. They had a lovely Negro model posing in a swell pose, and I just itched to get to work, but I had to wait until Monday. The stuff they do is very free and modern. André L'hote is very much influenced by Picasso, Matisse, Modigliani, etc., all the good moderns, as you can see by his work, which is nevertheless individual and very good. I like it a lot…We went to school at nine o'clock. André L'hote was there, he only comes Mondays and Thursdays, and gave the class

a wonderful lesson; especially for us he explained what he had told the others long ago. It was very interesting, as he made a sketch of the model, explaining as he did so all about unity of line, form, light, etc. he showed how one should find parallels of all the important lines in the pose (or in the figure and the composition), how it was good to repeat a curve or a line in another part, how one should always contrast a straight line with a curve, etc., lot of good points, told us in French of course, but we understood! We are getting quite good at French, and I hope we shall be quite good at painting…. Today André L'hote came and criticized. He only spends a few minutes on each of us, as there are so many. He got to ours last and wasn't very constructive with his criticism. He liked mine, said it had good color and wasn't bad for an American! He didn't like mother's, I guess it's not his type…" Arija included detailed ink drawings of their hotel room, their bathroom, and the bistro where they ate each day, even a stamp-sized portrait of André L'hote "from memory." One of the drawings is of Nick, seen from his right side, "rushing to the clipper though there is plenty of time because you are so excited about going to Europe to see your family." In another drawing, Arija and Leja are having breakfast at a "Parisian Garret," and one reads the newspaper while the other reads over her shoulder about a "famous photographer aboard the clipper."

The day after Arija wrote to Nick from Paris, Frida wrote to him from Coyoacán. She had received her Carbro portrait, which, after Diego admired it, she had hung in her studio. Frida wrote that she could see now how he had been in a no-win situation and jokingly blamed her jealousy on being Mexican. She had found intolerable that Nick was considering marrying the woman she had learned about upon her arrival in New York, although when Diego confronted Frida, she had been eager to tell him of Nick's impending marriage, as if that made the gossip of their affair untrue. By the end of the letter, Frida's newly

gained introspection has lost its focus and she shifts back to her usual playful, sexually teasing self, finally making some banal requests.

Coyoacán a trece de junio de 1939

Nick darling,

I got my wonderful picture you send to me, I find it even more beautiful than in New York. Diego says that it is as marvelous as a Piero de la Francesca. To me is more than that, it is a treasure, and besides, it will always remind me that morning we had breackfast together in the Barbizon Plaza Drug Store, and afterwards we went to your shop to take photos. This one was one of them. And now I have it near me. You will always be inside the magenta rebozo (on the left side). Thanks million times for sending it.

When I received your letter, few days ago, I didn't know what to do. I must tell you that I couldn't help weeping. I felt that something was in my throat, just if I had swallowed the whole world. I don't know yet if I was sad, jealous or angry, but the sensation I felt was in first place of a great despair. I have red your letter many times, too many I think, and now I realize things that I couldn't see at first. Now, I understand every thing perfectly clearly, and the only thing I want, is to tell you with my best words, that you deserve in life the best, the very best, because you are one of the few people in this lousy world who are honest to themselves, and that is the only thing that really counts. I don't know why I could feel hurt one minute because you are happy, it is so silly the way mexican wenches (like myself) see life sometimes! But you know that, and I am sure you will forgive me for behaving so stupidly. Nevertheless you have to understand that no matter what happens to us in life, you will allways be, for myself, the same Nick I met one morning in New York in 18th E. 48th St.[44]

I told Diego that you were going to marry soon.[45] *He said that to Rose and Miguel, the other day when they came to visit us, so I had to tell them that it was true. I am terribly sorry to have said it before asking you if it was O.K., but now its done, and I beg you to forgive my indiscretion.*

I want to ask you a great favor, please send by mail the little cushion, I don't want anybody else to have it. I

promise to make another one for you, but I want that one you have now on the couch downstairs, near the window. Another favor: Don't let "her" touch the fire signals on the stairs (you know which ones). If you can, and it isn't too much trouble, don't go to Coney Island, specially to the Half Moon, with her. Take down the photo of myself which it was on the fire place, and put it in Mam's room in the shop, I am sure she still likes me as much as she did before. Besides it is not so nice for the other lady to see my portrait in your house. I wish I could tell you many things but I think it is no use to bother you. I hope you will understand without words all my wishes.

Darling, are you sure it is not too much bother for you to arrange for me the question of the painting of Mrs Luce? Every thing is ready to send it, but I wish you could get for me only one detail that I need very badly. I don't remember the date when Dorothy Hale comitted suicide, and it is necessary to write it down on the painting, so if you could find out, by phone, somewhere I would be very happy.[46] *Not to bother you so much, please write down in a peace of paper the exact date and mail it to me. About the painting, you just leave it in your office (it is a small one) and as soon as you think that Mrs Luce is in New York, just call her up and let her know that the damn picture is there. She will send for it I am sure.*

About my letters to you, if they are on the way, just give them to Mam and she will mail them back to me. I don't want to be a trouble in your life in any case.

Please forgive me for acting just like and old fashion sweet heart asking you to give back my letters, it is ridiculous on my part, but I do it for you, not for me, because I imagine that you don't have any interest in having those papers with you.

While I was writing this letter Rose telephoned and told me that you got married already. I have nothing to say about what I felt. I hope you will be happy, very happy.

If you find time once in a while, please write to me just a few words telling me how you are, will you do it?

Give my love to Mam and to Ruzzy.

I imagine you must be very bussy now and will not have time to get for me the date when Dorothy Hale killed herself, please be so sweet to ask Mam to make for

me that favor, I can't send the picture till I know the damn date. And it is urgent that this wench of Clare Luce has the painting in order to get from her the bucks.

Another thing, if you write to Blanche Hays, tell her that I send all my love to her. The same, and very specially, to the Sklars. Thanks for the magnificent photo, again and again. Thanks for your last letter, and for all the treasures you gave me.

> *Love*
> *Frida*

Please forgive me for having phoned to you that evening. I won't do it anymore.

Nick remained troubled, grieving over the loss of a dream life with Frida, and uneasy with Arija and Leja's decision to extend their stay in France, given his concern over impending war. He preferred that Arija be in New York on August 11, her birthday. Nick was not used to being questioned and expected her to obey his rules without questioning them. She was growing up too fast, he thought, and although Arija was respectful, his will did not always prevail. He could hardly contain his displeasure when he wrote to congratulate her on her birthday, and Arija, who did not take his attitude lightly, was quick to remind him he was out of place. On August 18, she wrote from Saint-Meyme, in the Dordogne.

"Dear Dad;
I was a little disappointed and hurt by your short letter for my seventeenth birthday, which arrived a week late. In the first place, you spend the whole first page in accusing me of not having given you our address down here.

There you are entirely at fault. I sent you two long letters from here, the first of which you must have received long ago, and both of them had our address on the back flap, just as this one does. You always admonished me to put it there, and now when it is printed, you don't even see it! As for the rest of the letter, I expected something more sweet and personal something on my attaining seventeen,

the way you wrote me on my sixteenth birthday, last summer. Your letter has just cold bare news, and in it a brief reminder of my coming exhibition next spring.[47] Nothing remotely resembling a letter from a father to his only daughter on the occasion of her seventeenth birthday… and why must you assure me of love "no matter what happens!" That sounds as if there was some reason to doubt it. You shouldn't need to say that. It should be understood. Suppose I said that…. wouldn't you wonder what I meant?

Although you don't ask me about it, I shall be kinder than you and tell you about my seventeenth birthday and how it feels to be 17.

We celebrated it three days in advance, because Jean and Desha were leaving on the morning of the night to full-fill an engagement at Vichy. The day of the party saw Jean and I off early in the glorious morning to pick up the Roberts, Paris friends of D and J who are vacationing at a lovely little hotel 18 kilometers from here. We took them first to Lebuge, whose wonderful food I have already described to you in another letter, and after a long and sumptuous dinner started off on our trip to see some of the sights of the Dordogne.

First we went to Bayac and stretched our necks to see the great old castle standing majestically on the cliff towering over the little village at its feet. It was the only castle in all this part of the country that the English could not capture, no matter how long or hard they tried.

From Bayac to Domme, an old fortified village on top of a very high hill, practically a mountain; commanding a wonderful view of the Dordogne River, the field patterned valley, and blue hills in the distance. From the heights of the dome we descend to the same valley, and over the bridge that we have just seen spread before us in miniature from the jumping off place at Domme. And now our destination is our castle at Montfort.

It rises from a fairy tale castle from a hill overlooking the Dordogne. Old stone walls reaching up to shimmering slate turrets and roofs in the sun:

great cedars lending their dark height to the illusion of reaching for the sky … it is one of the most beautiful sights the imagination or reality could build.

Late in the afternoon we started back home silent and happy with the beauty we had seen.

Back at Saint-Meyme we (Jean and I, we had returned the Roberts to their hotel) found everything most delightfully arranged for the party. The round table, out under the young Elm on the terrace was covered with one of great-grandmother's white crotched and embroidered table cloths, on top of which was arranged a design of reed and yellow nasturtiums.

From the table, five long pieces of yarn led away in different directions, so long that their ends were hidden from the eye in the grass. After the simple supper, with cake and ice cream from Lalind for desert, I followed each one and found at the ends a lovely new lipstick, in pale blue and gold on the outside, from mother, and she notified me that tempera paints from Paris were on the way. Also she gave me and I gave her, a wonderful portable easel when we were in Paris so we both have one. Neat! From Desha, lotteries ticket which won nothing unfortunately and a promise of a bottle of perfume from Vichy. And a book, *Couple de Danse* from its author Jean Myrio,[48] with a lovely dedication in French; and of course I am not forgetting two earlier presents I received, from a certain daddy, which have brought and bought me much pleasure, the check and the radio. So that concludes my list of presents, very appropriate ones I think, for a seventeen-year-old girl. (I can just see you gazing horrified at the words "lipstick" and "perfume"! But they are both very becoming on me.) After finding all the presents and duly thanking and kissing all the givers – and here I send you one, with my new lipstick, which looks funnier than I expected, because I pursed my lips like a real kiss, which left a blank in the middle.

After doing this, we had one of the best champagnes in France, Veuve Cliquot and all drank to my health and happiness. I wonder what you were doing at the same hour. Seventeen is a very important age to me, much more so than 'sweet sixteen.' It is nicer too, since you are not taken as lightly, and considered, more important, a more mature age. Because now I have to shoulder more responsibilities, and think seriously of the future. I have been doing that for quite a while now and shall tell you my conclusions when I come back, which unfortunately won't be long now.

Love,
Arija

Desha said to put the lipstick on the upper lip over the true lip line, because it wasn't large enough, that is why the upper lip looks large here".

As early as March of 1939, Germany's annexation of parts of Czechoslovakia, not ceded by the Munich pact of the previous September, readied England and France to come to Poland's aid should Hitler also decide to invade it. On the following August 23, the nonaggression pact, signed in Moscow by Hitler's foreign minister Joachim von Ribbentrop and Stalin, looked more like a declaration of war, to the dismayed eyes of the world. In France, Prime Minister Edouard Daladier had ordered a general alert and mobilization, and gas masks were being distributed out of fear of chemical attack; monuments were being sandbagged in case of air raids; and art treasures were being secreted to predetermined hiding places. In light of the events, Nick must have been furious when he received Arija's letter. With war looming in the horizon, Arija and Leja's concerns with lipstick, ice cream and garden parties must have seemed to him preposterous. He had expected more from both, especially Leja. He wired them to come back to New York immediately. Arija's reply to his cable reminded him again how, despite her youth, her feet were on the ground, but that still, things were being done her way.

August 26, 1939

"Dear Dad;

Just received your telegram this morning and am going to wire back this afternoon, right after I finish this letter to tell you a little more than will be possible by telegram.

We all realize how grave the situation is, and are ready and prepared to meet it, if war comes. We could not be safer in America or anywhere else, for that matter, than here at Saint-Meyme. Besides it would be impossible to come back now, as mother wired to Paris the other day just to see, (she knew you would probably wire us.) and was informed that all the boats are filled. And ours, besides being a German boat, doesn't leave until September 20, if at all.

Here at Saint-Meyme we are far from any danger point, way out in the country, and we are not worried about having any refugees or people from the big cities thrust upon us, by last count. When they force the people to evacuate we shall be full with the five Desusclauds, (the father, colonel of aviation and oldest son, Claude would go to war or else there would be seven) and probably Nita, Raya, Star of the casino de Paris and Desha's best friend, and her parents. So we would be 11 in all, if Jean goes to the army. We have just enough room and sleeping places, including the beautiful big bathtub) to house this amount comfortably. No more so they wouldn't thrust any strangers on us. Also these people have enough money to share the expenses. Then, we have quite enough food here, together with what we would buy from Lalind, and from the Pisters our neighbors who would join forces with us and help with the garden and cooking, to suffice us very well. As for my school, Charlotte, oldest of the Desusclauds children, (she is about 29) is a schoolteacher from Paris, a very brilliant girl, and she could teach me in all the subjects, and especially in French. Desha would teach me to dance, and mother to handle oil paints. I have not yet grasped the real technique. As for amusement, I have loads of fun with the Desus-

clauds, and there are hundreds of things to keep us busy here. I will learn to sew, knit, and there are hundreds of good books here to read. As for clothes, it never gets terribly cold here in winter, and I have plenty of sweaters overalls and slacks, pair of winter shoes, and rubbers, and a warm suit. And will buy a warm coat at our friends, the Chentreils' store in Bergerac. Mother also. So you see we are all prepared, and there is no cause whatsoever for you to worry about us. Then of course we all hope it will be settled peacefully, but if it isn't we'll wipe the damn Germans off the earth once and for all and then have peace on earth. (We hope.)

All love,

Arija

Nick dear – Try not to worry too much, things might blow over again – if <u>not</u> we will hope for the best. Arija explained everything and we are safer here than in Paris for the moment. I hope you are well.

Best love,

Leja"

On September 11, just one week after signing the nonaggression pact with Stalin, Hitler, realizing everyone's worst fears, sent his army and Luftwaffe into Poland, destroying twenty towns on the first day. Two days later, England and France declared war on Germany, following its sinking of a U-boat

Frida Kahlo with Granizo, 1939 (version 1). Photo: N. Muray

Frida Kahlo painting *The Two Fridas*, 1939.
Photo: N. Muray

Frida Kahlo, *The Two Fridas,* 1939.
Col. I.N.B.A., Museo de Arte Moderno

tic Kelly clamp's effort, it continues to bleed. The idea for painting two identical Fridas holding hands came to Frida earlier that year, while in France, from paintings by Théodore Chassériau, *The Two Sisters*, and the anonymous Gabrielle d'Estrées at the Louvre, in which the two women look like mirror images.[50] As a photogra-

off the coast of Ireland. Still, that autumn, the general consensus in France was that the Allies' superiority in arms and men would not allow the war to last more than a few weeks.

Feeling reassured that Arija and Leja were safe in the Dordogne and would be back the following month, Nick traveled to Mexico. The relationship with Frida remained unsettled in his mind, although he was still considering marrying his American "wench." Nick photographed Frida and her pet fawn Granizo, and her sister Cristina with her children Isolda and Antonio. Using a timer, he took pictures of himself beside Frida, Rosa, and Cristina. In one, Frida's right hand curls around Nick's neck, caressing his cheek with her forefinger. Nick photographed Frida at her easel, painting the narrative self-portrait about her separation from Diego *The Two Fridas*. As identical twins, two Fridas sit side by side on a bench, holding hands. The one on the right wears a Tehuana costume; the other a white wedding dress similar to the one Frida's mother wore. Their exposed hearts are united by one common artery. Frida explained to American critic and friend MacKinley Helm that the Frida on the right is the Frida that Diego loves.[49] She holds in her hand a miniature portrait of Diego, out of which grows an artery that nurtures her and keeps her alive. The Frida on the left, the one Diego does not love anymore, receives blood from their common artery but is slowly dying, as despite the haemosta-

pher, Nick sought to capture something mysterious about the sitter, which said all but revealed nothing – a look, a gesture, an attitude – to hold the viewer's attention in wonderment, eager to decipher it, but unable to do so. The photographs of Frida painting *The Two Fridas* are visual puns to surprise the viewer with the three invented Fridas. All are similar, but each differs from the other two. One is even outside the canvas. Which is the real one? For another portrait, Frida is wearing the earrings shaped like a dangling hand that Picasso gave her in Paris. Her hand at her throat forms with one hand at each corner an invisible triangle between her ears and her chest. Among other photos of Frida, one stands out where Nick surprises the viewer by linking Frida to her pre-Hispanic roots and to her broken body. As our eye travels from left to right it correlates three beauties: on the far left is Frida, in the middle is the Olmeca idol she holds in her left hand, and on the far right is a hanging pot made of broken plates, in the center of which is the cracked body of a doll.

Nick, who had been lending Frida money each month – as she had refused to take any from Diego since her return from France – had chosen in lieu of repayment a painting. Miguel was to deliver the painting to Nick during his next trip to New York to curate the modern art section of the Museum of Modern Art *20 Centuries of Modern Mexican Art*.

When Nick decided to build a house in Mex-

ico, he deluded himself into believing that if they were geographically closer, he and Frida would have a better chance for some kind of a life together. At Frida's suggestion, Nick decided to speak to her friend Juan O'Gorman, the architect who had designed the twin houses in San Angel Inn for Frida and Diego, to find the land and design the house. After returning to New York and speaking with Frida he wrote:

… It was a great voice I talked with last night and gave me great joy and conviction that the wench who owns that voice is ok. Not by me but by the whole goddamn world! I wish I had magic in my hands I'd pick you up carry you above the clouds into the sun and have a talk with the guy who supposedly created the "Popo" [catépetl] … the cactus, and the world around, the little pigs, and Diego, and you, and me, and Miguel. – Maybe he would tell me the secret [of] how to make you well again so you could sing, and smile, love, and play again as I have seen you before in the bright sun or in the dark night.

But listen Kid – although I am not a woman, I too can have hunches (intuition, witchcraft, – presentiment) that the girl I talked to last night is on her way to recovery – her spirit is stranger than the angels (good or bad) and she has enough guts to battle any handicaps that comes her way.

Don't worry about money … Also don't worry about the exhibition and work and Julien You have a big job on your hands – to get well! I think its swell of Doctor Albee his offer of Florida sounds good to me, being the least exciting place, and would do better for you, than see a lot of bohemian guys in New York or San Francisco who would fill your ear with lots of art conversation. I called Julien but his phone is not connected which means the gallery is still closed for the summer.

…. I am very proud of you Kid – I see very much of myself in your character good and bad. I knew you'd stick with me and give and give if [I] needed anything you have.

Everything is ok. I started fencing yesterday. It makes me feel always good you know? I love to be strong and healthy. I have to be! Jesus! I'm starting to teach at New York University on the 25 September.

Write me as soon as you feel strong enough and want to write! I love you and always will.
Yours
Nick

Included with Nick's letter was a note from Mam:
Frida Darling – You've got the grandest guts that ever grew in a woman. I love you for everything and someday soon we're all going to get together and raise hell and laugh out loud.
Love,
Mam

Coyoacán, 13 de octubre de 1939
Nick darling,
I couldn't write to you before, since you left my situation with Diego was worse and worse, till came to an end. Two weeks ago we began the divorce. I have no words to tell you how much I been suffering and knowing how much I love Diego you must understand that these troubles will never end in my life, but after the last fight I had with him (by phone) because it is almost a month that I don't see him, I understood it is much better to leave me. He told me the worst things you can imagine and the dirtiest insults I ever expected from him. I can't tell you here all the details because it is impossible, but one day, when you will be in Mexico, I can explain to you the whole thing. Now I feel so rotten and lonely that it seems to me that nobody in the world has suffer the way I do, but of course it will be different, I hope, in a few months.

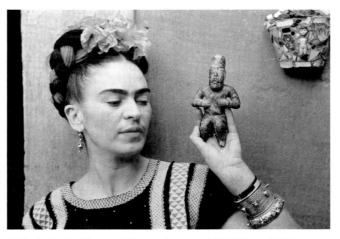

Frida Kahlo holding an Olmeca figurine, 1939. Photo: N. Muray

Darling, I must tell you that I am not sending the painting with Miguel. Last week I had to sell it to somebody thru Misrachi because I needed the money to see a lawyer. [51] *Since I came back from New York I don't accept a damn cent from Diego, the reasons you must understand. I will never accept money from any man till I die. I want to beg you to forgive me for doing that with a painting that was done for you. But I will keep my promise and paint another one as soon as I feel better. It is a cinch.*

I haven't seen the Covarrubias, so the photos you sent to them are still with me. I love all the photographs you were so sweet to send, they are realy swell. Thanks a lot for them. I send Diego your chek. Has he thank you for it? He didn't see the photos because I don't think he will be very much interested in seeing my face near his. So I kept them all for me.

Listen baby, please don't think badly about me because I haven't seen Juan O'Gorman about your house. It is only because I don't want to see anybody that is near Diego, and I hope you will understand. Please write to Juan directly. His address is Calle Jardín No. 10 Villa Obregón D.F. México. I am sure he will be very happy in doing what you wish.

I am so glad to hear that Arija is well and will be with you soon. I think you will bring her along to Mexico next time, wont you? I am sure she will enjoy it very much.

How about your own troubles? It is all set with the girl? In your last letter you sound happier and less preocupated, and I am glad as hell for that. Have you heard from Mary Sklar? When ever you see her tell her that inspite my negligence to write I do love her just the same as ever.

Tell Mam that I will send with Miguel the presents I promised her, and thank her for the sweet letter she sent me. Tell her that I love her with all my heart.

Thanks Nickolasito for all your kindness, for the dreams about me, for your sweet thoughts, for every thing. Please forgive me for not writting as soon as I received your letters, but let me tell you kid, that this time has been the worst in my whole life and I am surprised that one can live thru it.

My sister and the babies send their love to you. Don't forget me and be a good boy. I love you,
Frida.

Coyoacán. December 18. 1939.
Nick darling.
You will say that I am a complete bastard and a s. of a b! I asked you money and didn't even thank you for it! That is really the limit kid! Please forgive me. I was sick two weeks. My foot again and grippe. Now I thank you a million times for your kind favor and about the paying back I want you to be so sweet to wait till January. The Arensberg from Los Angeles will buy a picture. I am sure I will have the bucks next year and immediately I will send you back your hundred bucks. It is O.K. with you? In case you need them before I could arrange something else. In any case I want to tell you that it was really sweet of you to lend me that money. I needed it so much.

I had to give up the idea of renting my house to tourists, because to fix the house would cost a lot of money which I didn't have and Misrachi didn't lend me, and in second place because my sister wasn't exactly the person indicated to run such a bussines. She doesn't speak a damn word of English and would of been impossible for her to get along well. So now I am hoping only in my own work. I been working quite a lot. In January I will send to Julien two or three things. I will expose four paintings in the surrealist show which Paalen will have in Ines Amor Gallery. [52] *I think that little by little I'll be able to solve my problems and survive!!*

How is your sinus? How long were you in the hospital and how it worked? Tell me something about yourself. Your last letter was only about myself but not a word about how do you feel — your work — your plans, etc. I received a letter from Mary. She told me the magnificent news that she will have a baby. I am more than happy about it because Sol and herself will be just crazy of joy with a kid. Tell me about Mam. Kiss her one hundred times for me. Beginning in her eyes and finishing where is more convenient for both. Also kiss Ruzzy in the cheek. What is Miguelito and Rose doing? Are you coming with them to Mexico? I imagine you have already some other plans because you don't say a damn word about it in your letters. Is there another wench in your life? What nationality?

Give my love to Lea and to your baby. Were they happy in France?

Kid, don't forget about me. Write once in a while. If

Antonio and Isolda Pinedo with Cristina, their mother, in Coyoacán, 1939. Photo: N. Muray

you don't have much time take a piece of toilet paper and in…those moments…write your name in it. That will be enough to know that you still remember this wench!

All my love to you
Frida

January – 1940

Nick darling,
I received the hundred bucks of this month. I don't know how to thank you. I couldn't write before because I had an infection in the hand which didn't let me work or write or anything. Now I am better, and I am working like hell. I have to finish a big painting and start small things to send to Julien this month. The 17th it will be a show of Surrealist paintings and everybody in Mexico has become a surrealist because all are going to take part in it. This world is completely cockeyed, kid!! Mary wrote to me and sayed that he hasn't seen you for a long time. What are you doing? It seems to me that you treat me now only as a friend you are helping, but nothing more, you never tell me about yourself, and not even about your work. I saw "Coronet" [53] *and my photo is the best of all the other wenches are ok too the one of myself is a real F.W. (Do you still remember the translation? "fucking wonder")*

I think Julien will sell for me this month or next a painting to the Arensberg (Los Angeles). [54] *If he does, I told him to pay back to you the money you already send*

me because it is easier to pay little by little than to wait till the end of the year – don't you think so? You can't have <u>any idea</u> *of the strange feeling I have owing you money. I wish you would understand. How is Arija? and Leja? Please tell me things of yourself!!! Are you better of your sinus trouble? I feel lousy. Every day worse and worse. Anyway I am working – but event that. I don't know how and why? Do you know who came to Mexico? That awful wench of Ione Robinson. I imagine she thinks that the road is clear now!… I don't see anybody. I am almost all day in my house. Diego came the other day to try to* <u>convince</u> *me that nobody in the world is like me! Lots of crap Kid. I* <u>cant</u> *forgive him – and that is all*

———

Your mexican wench.
Frida
<u>My Love to Mam</u>.
How is this New Year for you? How is Joe Jings? How is New York? How is the La Salle? And the woman you always shooted?

Feb. 6. 1940.
Coyoacán.

Nick darling,
I got the bucks – thanks again for your kindness – Miguel will take one big painting for the show on the Modern Museum. The other big one I will send to Julien. [55] *He proposed me to have a show next november so I am working hard. Besides I applied for the Guggenheim, and Carlos Chavez* [56] *is helping me on that, if it works I can go to New York in October – November for my show. I haven't sent small paintings to Julien because it's better to send three or four than one by one.*

What about you? Not a single word I know about what the hell are you doing. I imagine all your plans about Mexico were given up Why? Do you have another wench? A swell one? Please Kid tell me something. At least tell me how happy you are or what on earth are you thinking to do this year or next.

How is little Mam? Give her my love.

I have to give you a bad news: I cut my hair, and looks just like a ferry. Well, it will grow again, I hope!

How is Arija? And Leja? Have you seen Mary and Sol?

Write to me, please, one evening instead of reading Joe Jings, remember that I exist in this planet.

Yours

Frida

Nick had not forgotten Frida… he couldn't, but what he was searching for was a different perspective from which to approach her. He had gone along with her and the relationship seemed to work for a while; but obviously in the end, it had not. What did she want? What did she really want?

She wanted Diego, she wanted Nick, and she seemed to want everything without paying the price. Nick had been his usual self, clear, direct, upfront, but at the same time reserved, not telling all he observed, what he perceived. Possibly, he questioned what good would it do. Being blindly devoted, without questioning her motives, had backfired. He could see that what mattered most to Frida was the effect she had on others, how her life revolved around what impression she made, and all else followed. Her life was an act of sorts and all the rest – her relationships, her painting – spun out of it. So he decided to approach her with certain distance yet at the same time without inhibiting his perceptions as they surfaced. After this, she could not question that he knew what "her sweet little number" was about. He knew much of her demeanor was an act…. she did not need it with him. He knew the way she was and loved her unconditionally. Her spot in his "bosom" was there to stay.

April 6 1940

Just feel like writing you baby! Maybe cause its spring; – or 'cause I just got your funny short little wire about the dough. You are a bright wench, and we didn't have to beat around the bush. You can get hurt, mutually misunderstood but all that doesn't matter to me. I hold a record in the U.S.A. of having very few friends in the true sense of the word – in Hungary we used to call it "bosom friends" meaning exactly that, that once a fellow or girl you embraced, taken into your "bosom" there they stay unless they really become horrible bastards. If just a little

bastard or bitch that's ok, 'cause nobody is a 100% angel. I'd have no use for one, except in a museum. I read both your letters to Mam, I got sore at you. 20 years ago, (before I became a bookish philosopher) I would have beaten the tar (shit) out of you but now I want, like a wise old man, to let her Mexican temper subside and then talk sense with her cause baby you have more than you pretend not to have. Listen baby I understand well, Coyoacán, Mexico, on the whole the attraction of the majority of your friends, sweethearts, lovers, husbands, revolves mostly about the (you know what I mean) sweet little number – everything else comes after if you have energy money, [and] work – if all this is convenient. And I agree with you, cause compared with it, fencing, working, painting, making money – becomes very second class… But, screwing also becomes second-class if you overdo it. It's an art by itself. It must be dressed up, covered up to make you crazy to want to uncover it. It shouldn't be like you say a bakers bread, that you put dough in the oven bread comes out. It should be an art – any art. I love to look at good exciting paintings. If I were a painter, I would alternate one day painting – not much – 4-5 hours a day, next day (maybe) a little loving – 4-5 hours. The rest could be divided by eating, sleeping, and being social. I should include reading….

In the beginning of this letter I said no beating around the bush – but your bush is so heavenly to beat around! (I remember). What news of your Guggenheim scholarship. Are you coming to New York, when? Your bathtub picture I shall loan to the Museum of Modern Art for their Mexican show. I hear nothing from Miguel, that's ok! Yes I have a wench a swell one – Irish, black hair but she lives in the west. I have wenches here too – but only two times a month. I am nuts about flying and I'll be a goddamn good pilot. It looks like I may get to your beautiful country around the middle of June.

Best to your sister and you, you little bitch, I will always love you,

Your Nick

Nick liked receiving news from Frida, and on April 14 he replied, "Your nice long letter was like a

Critic Justino Fernández,
Rosa, Frida in bed, and
Cristina in hospital, 1940
Photo: N. Muray

Frida Kahlo in traction, 1940
Photo: N. Muray

tonic for my spirit. It was like angels singing in the cathedral of my heart, very intelligent angels!" He informed her that he was working hard and receiving more awards and more medals for his work. He had spent a weekend with Edward Steichen who had remembered Frida and asked affectionately about her. Arija had wanted to spend time in Mexico working with Frida and Diego, and Nick was also very pleased and grateful that they would be happy to have her working with them in their studios; she could stay across the street, at the San Angel Inn Hotel. Nick and Arija planned to fly via Boston and arrive in July; she would stay about four or five weeks and he, after visiting briefly, would travel to Acapulco to meet his friend the silversmith Bill Spratling. Nick wrote to Frida as if nothing had happened, joking but also serious: "I followed your advice about the wench." Nick had developed gout but did not mention the seriousness of the problem, not to Frida, not to anyone. He could hardly walk after having had a "massive attack. I was on crutches for three weeks and even moved temporarily into a hotel across the street from my studio so that I might continue some measure of my work." He still put in full days and no one knew, other than his physician, that he was in excruciating pain; he directed operations in his studio from a chair. Eventually, he would accept that the reason why the standard medication Colchicine and diet were not working for him was because his gout was not caused by a physical problem but by tension: "My doctors and I have decided that my gout attacks stem from emotional upset."[57]

Nick went to Mexico earlier than planned. At the end of May, on the 29th, pro-Stalinists, including muralist David Siqueiros, attempted to assassinate Trotsky, but he and his wife Natalia rolled out of their beds onto the floor and survived. He would not be as lucky three months later, when on August 20 Ramón Mercader killed Trotsky by sticking an ice pick in his head. Diego was an immediate suspect due to their well-publicized falling out, but he was able to escape from his home hidden in the back of his assistant Irene Bohus's car. He was secreted, fed, and cared for by Bohus and Paulette Goddard, on whose portrait he was working, long enough to get a passport (through friends in high places) so he could travel to San Francisco, to paint a mural for the Golden Gate International Exhibition. Frida became ill after the assassination attempt and was hospitalized for the next three months. Nick visited and photographed her in the hospital, in traction, and in the company of art historian Justino Fernández, and with Rosa and Cristina.

Arija's trip to Mexico City was postponed indefinitely as Frida, shortly after leaving the hospital, followed Diego to San Francisco where they remarried, on December 8, 1940. The next day, she received two congratulatory telegrams in care of Dr. Eloesser. One from Mam, and one from Nick: "My blessings on both your houses…"

Their affair essentially over, Frida was more open about her other love interests. After her wedding, she traveled to New York with Heinz Berggruen, a Nazi refugee who was doing public

relations at the Golden Gate International when Diego introduced them. They stayed at the Barbizon-Plaza Hotel for nearly two months.

During the spring term of 1941, Nick was named Director of Courses in Color Photography at New York University and taught the advanced course. Frida had lost her adored father to a heart attack on April 14, and reflectively, she painted a self-portrait dressed in mourning, recreating the life cycle of a butterfly on the leaves of a rubber plant behind her. That August, Nick and Arija finally traveled together to Mexico to visit Frida. He took many photographs of Frida and some of her with Diego in their San Angel home. In one, standing in a semicircle behind a sitting Diego, are Ione Robinson, Frida, Nick, Emmy Lou Packard (Diego's assistant), and Arija. Another shows Frida and Arija leaning on the table, their heads inclined toward each other, touching, a wine glass in front. Neither could have predicted that after this trip, he would never return to the intimacy of her home as he had so many times before.

Strangely, as if closing a circle, during a moment of closeness, Nick took a stunning self-portrait with Frida in her studio, surrounded by her world: a full-length mirror, pre-Hispanic figures resting on racks, paintings hanging on the walls. In one shot, Nick's astute eye took in the players, the environment, and the complexities of their relationship, creating a context that brought them all together in a dynamic photograph. Uncannily, Nick exposed their affair, from beginning to end as objects play off one another. With her back to her mirror, Frida sits at her easel, which holds her self-portrait *Me and My Parrots.*[58] With a sad expression she stares at the camera; Nick, standing to the other side of the easel, turns his infatuated look on her. The parrots sitting on her shoulders in the self-portrait mirror the position of lovers: one is turning toward the one who faces forward; the two parrots on her lap turn away from each other, as Nick and Frida will do very soon. In the back, on a rack slightly above Frida's head, rests a red terracotta marital couple from Ixtlán del Río,[59] in which the two figures are attached as one. Hanging on the wall above the couple is a painting by Diego of a sexual triangle of three anthropomorphized cacti in the desert. The shadows of the two "male" cacti, like erect penises are directed toward the round-breasted "female." The painting was done in 1931, the year when Nick and Frida began their affair.[60]

Less than a month after their visit to Mexico, on September 19, 1941, at 5:45 p.m., Arija Muray

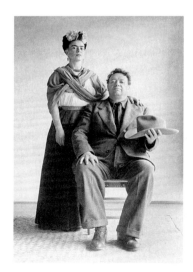

Frida and Diego in San Angel Inn, 1941. Photo: N. Muray

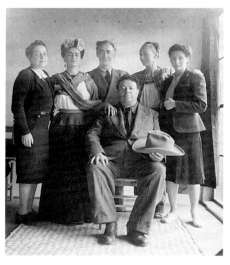

Ione Robinson, Frida, Nick, Diego (sitting), Emmy Lou Packard, and Arija in San Angel 1. Photo: N. Muray

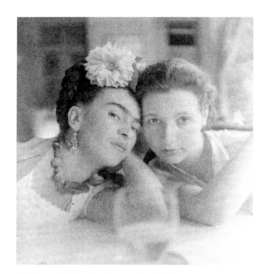

Frida and Arija in Coyoacán, 1941 Photo: N. Muray

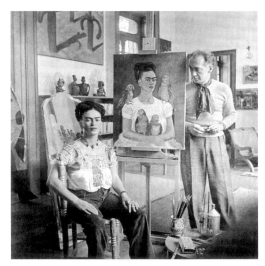

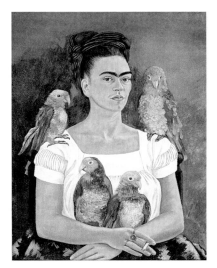

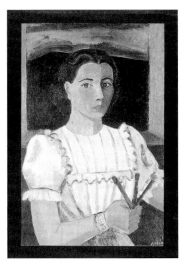

Self-portrait with Frida Kahlo in her studio and on her easel her self-portrait *Me and My Parrots*, 1941. Photo: N. Muray

Frida Kahlo, *Me and My Parrots*, 1941. Private collection. Photo: Collector

Arija Muray, *Self-Portrait in San Miguel Allende*, 1940. Whereabouts unknown. Photo: N. Muray

died in Manhattan's New York Hospital.[61] She had turned nineteen just a month earlier in Mexico. Prior to returning to New York, she had traveled to Vera Cruz against Nick's wishes. When she contacted Nick, she was feverish and growing worse. Angry at her disobeying him, Nick hesitated, but flew her back to New York, where she was hospitalized. She underwent tests and treatments, but to no avail; two days later, she was gone.

Desperate over the loss of Arija, unable to find consolation, Nick reached out to Frida. He asked her to paint a portrait of Arija and sent her photos of the girl. He wanted her portrayed wearing a Mexican blouse like the one she wore in a self-portrait she had done the previous year, which was also like the one Frida wore in her self-portrait *Me and My Parrots*.[62] Frida cabled her condolences, agreed to do the portrait, and promised to write.

Dear Frida!
I am trying hard not to become a hypochondriac or develop a persecution complex. Everything seems to go wrong; even letters I hope to get don't arrive.

This is your second telegram since I have seen you. I have been in a daze since my Arija left me; if I could exterminate the Doctor profession I think I could be a little happier. They are a bunch of fakes making wise faces

and know so damn little. They killed her with an overdose of medicine. I wish I had been her.

Thank you Frida. I know you loved the kid too, everybody who knew her couldn't help it, she had great and sweet qualities, and if I live a hundred years I'll never be as bright and intelligent as she was. Every time I see her pictures, my stomach goes into a revolution I've got no guts to stop living. I go on like a machine the same damn block each morning the same office the same lunch places the same fifth avenue the same faces, nothing happened to them. The world is the same stinking brutal world. I'd like and I'll probably go to the devil somewhere nobody knows me and live in a shack and talk to myself as I already [have] been doing.

I can't even stand poor Leja, she reminds me of her all the time, and I hurt her by not being able to feel love for her.[63] The poor Dear loves me I can't return her love. I feel like a beast, like a mule, who wants to go his way and does not know his own desire which way to go.

Even the sympathetic people make me furious [when] they are sweet, nice to me, their sweetness just rip[s] my heart open every time they speak of Her.

I joined New York University to study navigation and meteorology for eventual flying and next spring I will take up flying seriously.

I am trying to concentrate on something if I can.

I hope you got these two prints; one was taken last

year the other younger one when she was 14 years old but I love her expression on the younger one.

If you could put a Mexican blouse on her probably white. I don't know how to draw — with broad blue stripes, she painted a self-portrait in San Miguel, Allende, I am sure you will know this Mexican material linen.

Sorry to hear about Diego's eyes; this weekend I am flying to the Dartmouth Eye Institute [in] New Hamp-shire to have my eyes examined, if I read ten minutes everything blurs.[64] I hear it is a wonderful institute with revolutionary new method examinations [that] takes 6-8 hours. Give my best to Diego and to you — my love. Please write me soon.

Your Nick

By November, just two months following Arija's death, Nick was following his own advice, the advice he had given to Frida when she had been in the depths of her depression over the loss of Diego: he picked himself up by his bootstraps, and he worked, worked, worked. He felt "almost perfect," he informed her. *[I]nstead of going nuts I made up a schedule taking up almost every minute of my waking hours. I built up physically a body — fine machine. I have been playing tennis 3 mornings a week... I just engaged a fencing coach — two mornings a week, and fence two evenings a week, and I took up navigation for my flying ground exams for aeronautics in New Mexico... How is Diego I sympathize with him, without eyes...*

But as much as work redirects energy and distracts the mind, the only thing that will aid the healing process is facing the problem head on. Nick's heart had been broken: he lost a child *and* he lost a friend...

Dear Frida,
Your last wire on October 24th indicated a letter, which I never got. I sent to you a long letter after I came back from Santa Fe, and two color photos of Arija for you — and heard nothing from you. I know it must be difficult for you to be sister, mother, father, lover, husband — and friend, and you are trying to be all including a nurse and a painter and here I am yapping and longing, complaining why I don't hear from you! After you read this letter put it on top of all unanswered mail and cover me up with new ones that come and when you are in the mood — I know you will do something — You'll sort your mail selecting the ones you like to answer, I hope I'll be in the select few...

Frida never wrote to Nick again. Nor did she ever paint the promised portrait.

Afterword When Danny Jones was hired at the studio, after Arija's death, Mam gave him this cryptic message: "There is one word you never speak here because it would upset Mr. Muray. Don't ask me why. I am telling you privately, don't do it; one day I'll explain to you why, the word is Arija." Wanting to know why, Danny asked Caroline Eric, who was a friend of Nick's and companion to his uncle Bradford Norman. "What was that about?" Danny asked Caroline. "Don't ask," she replied, "just don't use it. It is the name of Nick's daughter who died a teenager. It threw Nick into a terrible despondency and despair."

"I remember one day," Danny recalled, "we were going through one stack of Carbros, and we came upon a photo of Anna Mae Wong, 'do you know her? She is quite a lady.' And then upon another print, and he flipped it over and was just standing there. 'Who is that, I asked him?' 'It was a daughter of mine,' he replied, and he set it aside. It was the only time we ever spoke about her. It was the subject I never knew anything about."

Shortly after Arija's death, Nick exhibited Frida's portrait with the magenta *rebozo* in the Members Show of the Coffee House Club in New York, and Frank Crowninshield told him "it was the best color photo he has ever seen." On July 23, 1942, Nick married Margaret (Peggy) Schwab,

twenty-four years his junior. Their daughter Michael Brooke (Mimi) was born on June 7, 1943; she was named after Miguel Covarrubias, her god-father. Nicholas Christopher was born on December 24, 1945.

Nick and Frida met again in New York, in 1946, where she came to have a spinal fusion. Nick photographed her on the rooftop of his duplex on 230 E. 50th St. with the skyscrapers behind her. She arrived with Cristina, her younger sister, and Josep Bartolí, her current lover. The following year, Diego copied Nick's portrait of Frida in his mural *Dream of a Sunday Afternoon in the Alameda* (1947-48).

Nick and Peggy traveled often to Mexico City with the kids where they spent the Christmas holidays as guests of their old friends Olga and Rufino Tamayo. In December 1951, Nick took his family to visit Frida in her blue house on Allende Street. She had just returned home from a lengthy stay in the ABC Hospital following spinal surgery, and she was glad to see them. As a parting gift, Frida gave them a small still life painting with a watermelon and a parrot, which she had withdrawn from the Galería de Arte Mexicano's inventory just for them.

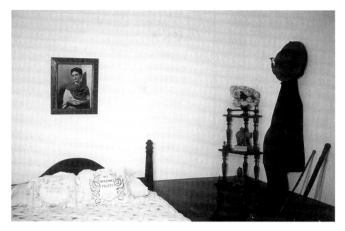

Diego Rivera's bedroom in the Frida Kahlo Museum in Coyoacán with Nick's portrait of Frida hanging over his bed. Photographer unknown

They did not meet again.

Frida died on July 13, 1954, of unclear reasons; on February 4, 1957, Miguel, who died of septicemia, followed her; Diego died on November 24, 1957 of heart failure. Nick died on November 2, 1965, of a heart attack, while fencing.

On July 12, 1958, the Frida Kahlo Museum opened in Coyoacán. Nick's portrait of Frida's adorns the cover of the museum's catalogue; it also hangs in Diego's bedroom, above his bed, from where she is looking at Nick adoringly. Forever.

NOTES

1 Nickolas Muray had a reputation for being irresistible to women. His friend Miguel Covarrubias drew a caricature of Nick as "Lady Killer," dressed in his white fencing uniform, with a bright red heart on the left side of his chest. Illuminated by a floodlight in the photographer's studio, he smiles triumphantly, waving at the spectator, one foot over the nude body of his recent victim. The undated portrait is in the collection of the Smithsonian Institution, Washington, D.C.

2 During her adolescent years, Mimi Muray read her father's correspondence from famous people, given to her by her mother. She wondered about the passion Nick had stirred in Frida Kahlo and why her mother did not destroy the letters.

3 I am deeply grateful to Dr. Andor Gellert, in Budapest, for his generous help in helping me find Nickolas Muray's birth certificate in Szeged, and for the history around his family's change of name.

4 Ursula Parrot, an award-winning author, was Nickolas Muray's lover during the late twenties. Taking the personal information he had given her, she wrote – without intention of publishing it – "a profile for a New Yorker," and gave it to Nick as souvenir. I referred to this text, plus complementary information gathered from Nick's nieces Cornelia Muray Braun, Ilona Muray Kerman, and Violet Muray Tamas, about his early and family life.

5 Nickolas Muray's work history has been pieced together from information from various sources in Mimi Muray's archives.

6 Nick began fencing in Chicago, in 1918, when he joined the German Turnverein. He won his first competition the following year. He was inducted into the Fencing Hall of Fame on July 1, 1978.

7 Desha became first dancer in Michel Fokine's company. Frishmuth also used her as model when she sculpted *Desha* (1927) and *Roses of Yesterday*

 (1923). Eventually, Desha married Mario Delteil.

8 Telephone interview with Ilona Muray Kerman, October 5, 1996.

9 I thank Rosa Lozowsky for her generous help at the Miguel Covarrubias Archives in Mexico.

10 The most comprehensive study of Frida Kahlo is by Hayden Herrera, *Frida: A Biography of Frida Kahlo* (New York: Harper & Row, 1983). Henceforth, *Frida.*

11 Herrera, *Frida,* 51.

12 Personal interview with Lucienne Bloch, September, 1987.

13 According to Herrera, "on June 8, 1931, five days after he finished the fresco, Frida and Diego flew to Mexico," *Frida,* 126. But Frida's note to Nick, dated "May 31, 1931 Coyoacán" suggests that she must have arrived in Mexico before Diego.

14 Copies of Frida Kahlo's letters to Nick Muray are in the Mimi Muray archives.

15 I thank Dr. Agnes Whitley for translating Frida Kahlo's letter from the Hungarian and for her insightful observations.

16 See Robert W. Marks, "Portrait of Nickolas Muray," in *Coronet,* October 1939, 19-27.

17 He was a competitor on the U.S. Olympic teams of 1928 and 1932.

18 See Bertram D. Wolfe, *A Life In Two Centuries: The Autobiography of Bertram D. Wolfe* (New York: Stein and Day, 1981), 587.

19 See Arija Muray's correspondence with Nick Muray, in the Mimi Muray Archives.

20 Sometimes Arija and Leja spent vacations here, at the home of "Auntie Harriet" (Frishmuth).

21 Frances B. Berdau and Patricia Rieff Anawalt, *The Codex Mendoza* (Berkeley: University of California Press, 1992), vol. 1, 168, appendix E.

22 Caroline Larrington, ed., *The Feminist Companion to Mythology* (London: Pandora Press, 1992), 376-78.

23 I thank Emmy Lou Packard for providing me copies of Frida Kahlo's correspondence, as well as the photograph of Frida Kahlo's bedroom and other photographs of Frida Kahlo and her home, taken in 1941.

24 Undated letter from Miguel Covarrubias to Nickolas Muray in Mimi Muray's archive.

25 Quoted in Diana Edkins, "Pioneers of Commercial Color: Bruhel Keppler Muray Outerbridge Steichen" in *Modern Photography*, September 1978, 104-9.

26 Loló de la Torriente tells how "When Frida would give him little nips, he'd get upset. It was his vulnerable point." See her *Memoria y Razón de Diego Rivera* (México: Editorial Renacimiento, S. A., 1959), Vol. II, 284.

27 For the catalogue of Diego Rivera's 1949 retrospective at the Instituto Nacional de Bellas Artes, Kahlo wrote a "Portrait of Diego" quoted in its entirety in Martha Zamora's *Frida El Pincel de la Angustia* (México: M. Zamora Publications, 1987), 205-21.

28 It is likely that Nick and Blanche Hays, the Provincetown Theater's costumer, became friends through the playwright Eugene O'Neill, who Nick befriended long before he was known.

29 Mary Sklar, the art historian Meyer Schapiro's sister, owned two works by Frida, the still life *Tunas* (1937) and the self-portrait *Fulang Chang and I* (1937). The latter, a gift from the artist, is now in the collection of the Museum of Modern Art, N.Y.

30 This portrait is in the collection of the National Portrait Gallery, Washington, D.C

31 This portrait is in the collections of the Frida Kahlo Museum, Mexico; the George Eastman House, Rochester, N.Y.; and The Metropolitan Museum of Art, N.Y.

32 Frida refers to the short-lived Galerie Gradiva, which opened in Paris in May 1937, for less than a year.

33 The photographs of Manuel Alvarez Bravo (1902-2002) made a profound effect on Breton, and he used eleven of them to accompany his essay on Mexico, "Souvenir de Mexique," in the surrealist publication *Minotaure*, May 1939.

34 All this popular art sold for exorbitant prices in April 2003 during the sale of the André Breton estate sale.

35 He was married to Frida and Diego's friend Anita Brenner, author of the novels about the Mexican Revolution *Idols Behind Altars* and *The Wind that Swept Mexico.*

36 Frida had been invited by Peggy Guggenheim to exhibit at her London gallery Guggenheim Jeune.

37 Joe Jinks and his nagging wife Blanche were newspaper cartoon characters created by Vic Forsythe in 1918. Jinks was a short, middle-aged, balding guy usually agitated because of trouble with his car, often yelled at by frustrated drivers to "get a horse!"

38 George Worth fenced for the Club Salle Santelli and Nick for the New York Athletic Club when they met in May 1937. Nick and Peggy, his last wife, and George and Karen became friends until Nick's death.

39 She refers to an album by Maxine Sullivan, a jazz vocalist who, in June 1937, became enormously popular with what became her trademark song "Loch Lomond," a swing version of a Scottish folk song.

40 Frida refers to the photographs that Nick made of her paintings for Breton's use at the time of her show. They were sold in Breton's estate sale, in April 2003.

41 Michel Petitjean reported to Herrera an affair Frida had while in Paris. See *Frida*, note 246, 473.

42 Bertram C. Wolfe, *A Life in Two Centuries*, 647.

43 Most likely, "R" refers to Rosa Covarrubias as the one who told Diego about Frida's affair with Nick. Off and on, she and Miguel quarreled about Nick's covering for Miguel with women 'friends' with whom he'd meet in New York. References to this conflict are referred to in each letter from Miguel to Nick, in Mimi Muray's archive.

44 This is the address of Nick's Studio.

45 The facts of this marriage, if it ever took place, remain unclear. According to Mimi and Ilona Muray Kerman, who was Arija's age and closer to Nick than the other nieces, Nick married four times. Nick told Danny Jones that he married "four times and two of them are dead." The two who died must have been Ilona Fulop and Monica O'Shea, as Danny knew Leja and Peggy. Chris Muray recalls visiting, in his adolescence, "a lady in Canada, who had been Nick's fourth wife." He grew up with the belief that Peggy, his mother, had been Nick's fifth wife. I have not been able to confirm this marriage mentioned in Frida's letter and by Chris.

46 Frida refers to the commissioned portrait of Dorothy Hale by Clare Booth Luce, *The Suicide of Dorothy Hale* (1938-9), which she began in New York, exhibited unfinished in Paris, and finished in Mexico. The painting was given anonymously by The Honorable Clare Booth Luce to the Phoenix Museum of Art.

47 Nick organized a solo show for Arija at his studio, where, Leja recalled, "he invited several art gallery friends, all of whom were interested in acquiring her paintings, he refused to sell a single one and marked all of them with a red star." Letter from Leja Gorska to Peggy Muray, dated December 6, 1965, in Mimi Muray's archive.

48 Desha, Jean Myrio, and Leon Barté became famous for their interpretation of George Gershwin's *Rhapsody in Blue,* filmed at the Kit Kat Restaurant on Piccadilly Circus in London.

49 MacKinley Helm, *Modern Mexican Painters,* (New York: Dover, 1968) 167-68.

50 Jacqueline Lamba took Frida to visit the Louvre while in Paris. I thank Fernando Gamboa, friend of Frida's, for sharing with me, in 1989, the iconographic source of *The Two Fridas.*

51 In The Misrachi Gallery archive there is no record of a painting that Frida sold in 1939. *The Dream* (1940) sold to Luis de Hoyos by Misrachi Gallery for $300 after returning to Mexico, unsold, from Julien Levy's gallery. A color transparency of the work, taken on the rooftop of Nick's duplex, is in the Muray photographic archive in the collection of Mimi Muray.

52 Frida met Austrian surrealist Wolfgang Paalen in Paris, as he, his wife Alice Rahon, and their lover Eva Sulzer were about to travel in the U. S. Northwest and Canada. She invited them to visit Mexico, which they did as WWII broke out. (They settled in Mexico, where they eventually stayed.) In 1940, Paalen, with the help of Breton and Peruvian poet César Moro, organized the International Surrealist Exhibition at the Galería de Arte Mexicano, directed by Inés Amor. Frida exhibited two works, *The Two Fridas* (1939) and *The Wounded Table* (1940).

53 The October 1939 issue of *Coronet* had a laudatory "Portrait of Nickolas Muray" by Robert W. Marks: "his every picture is a shot at perfection," said the author. Frida's portrait was in good company, with Luise Rainer, Ginger Rogers, Anna May Wong, George Bernard Shaw, Greta Garbo, Claude Monet, and H.G. Wells.

54 The sale was to be completed through Emmy Lou Packard. In a letter dated December 15, 1941, Frida writes to Emmy Lou that *My Birth* (1932), which is the painting Walter Arensberg wants, has been sold to Edgar Kauffmann, but that "Me Suckling" (*My Nurse and I*, 1937) its companion, is available, if they are interested.

55 She refers to *20 Centuries of Mexican Art* at the Museum of Modern Art to which Frida lent *The Two Fridas* and Nick *What the Water Gave Me*. The large painting she refers to is likely *The Dream* (1940).

56 Carlos Chávez (1899-1978) was a renowned Mexican conductor, composer, and educator. He was a close friend of Frida and Diego's until 1952, when they severed all ties with him after he refused to send Diego's last mural, *Nightmare of War and Dream of Peace* (1952) to the Exhibition of Mexican Art in Paris; Frida referred to him as "anti-Mexican" and "sheltered by the filthy shadow of Imperialism" in an undated letter in a private archive. In 1942, Chávez had bought from Frida the still life tondo that had been returned to her by Mrs. Manuel Avila Camacho, the President's wife; Frida asked to varnish it and refused to return it. After she died, as Carlos Pellicer was preparing the Frida Kahlo Museum, he discovered the painting face down over the canopy of her bed. Personal interview with Lola Alvarez Bravo.

57 Letter from Nick to Dr. Ivor Fix, dated June 26, 1963, in Mimi Muray's archive.

58 This painting has been variously dated; but on the back of the linen canvas Frida wrote with brown paint: "Yo y mis pericos" Coyoacán. Agosto de 1941. - Frida Kahlo.

59 Frida used this figure from Nayarit, c. 100 A.D., as model for the figure she is attached to in *The Wounded Table*; it is currently in the collection of the Frida Kahlo Museum.

60 Titled *Paisaje con cactus* (1931) it is part of the Jacques and Natasha Gelman Collection, Mexico.

61 Arija's death certificate is in Mimi Muray's archive.

62 In the letter, Nick actually makes a drawing of the blouse close enough to identify the resemblance.

63 In a letter from Leja to Peggy written after Nick's death, on November 22, 1965, she writes: "When I lost Arija – I forced myself to remind me of all the mothers who were losing their sons in the war at the time and it helped to keep my mind centered off my own hurt and irreplaceable loss…"

64 Diego was suffering from conjunctivitis, which subsided with "Sulphamidyl." Nick's eye problem was psychosomatic; it began after Arija's death; eventually, it subsided without treatment.

Plates

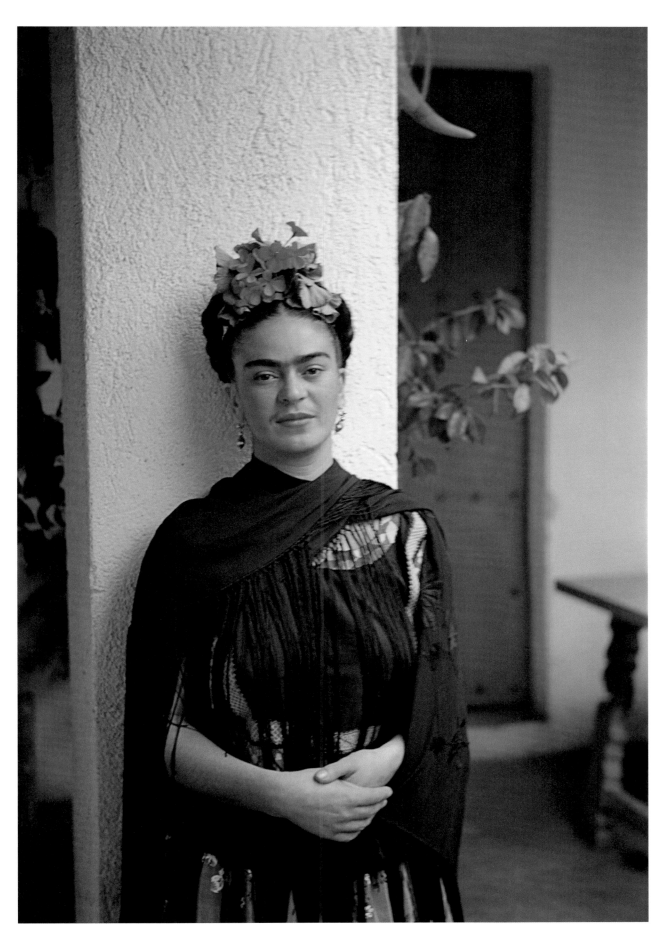

1

Frida, Tizapán

1937

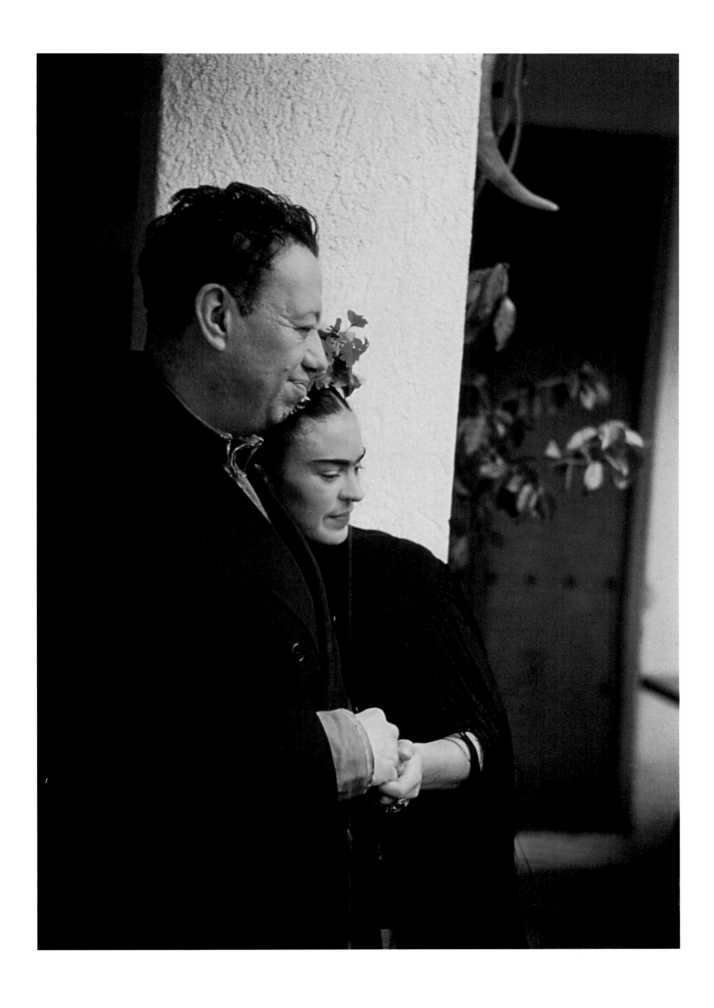

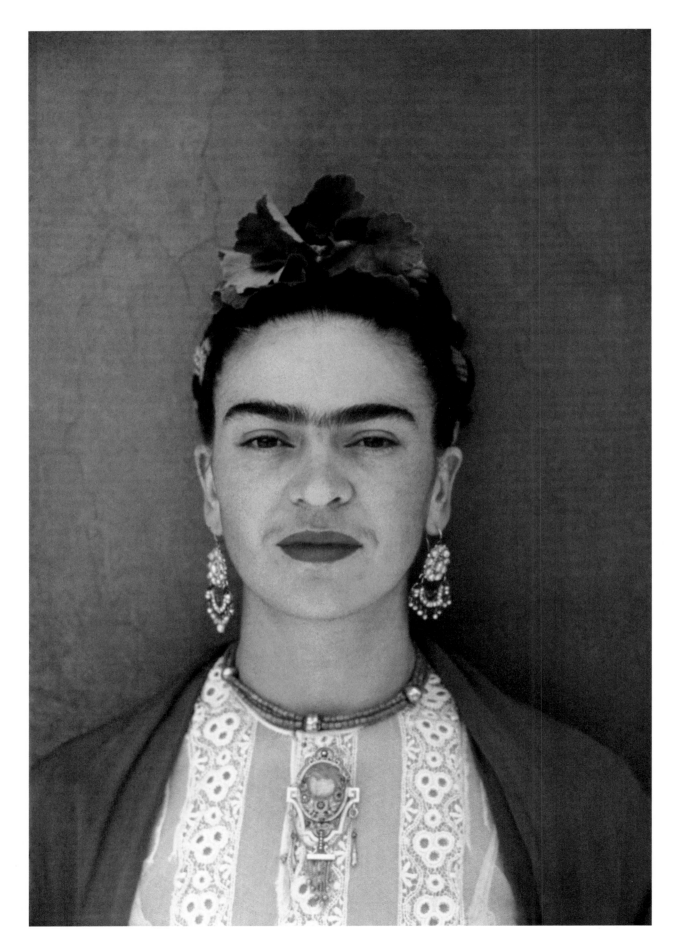

3
Frida, Countryside
1938

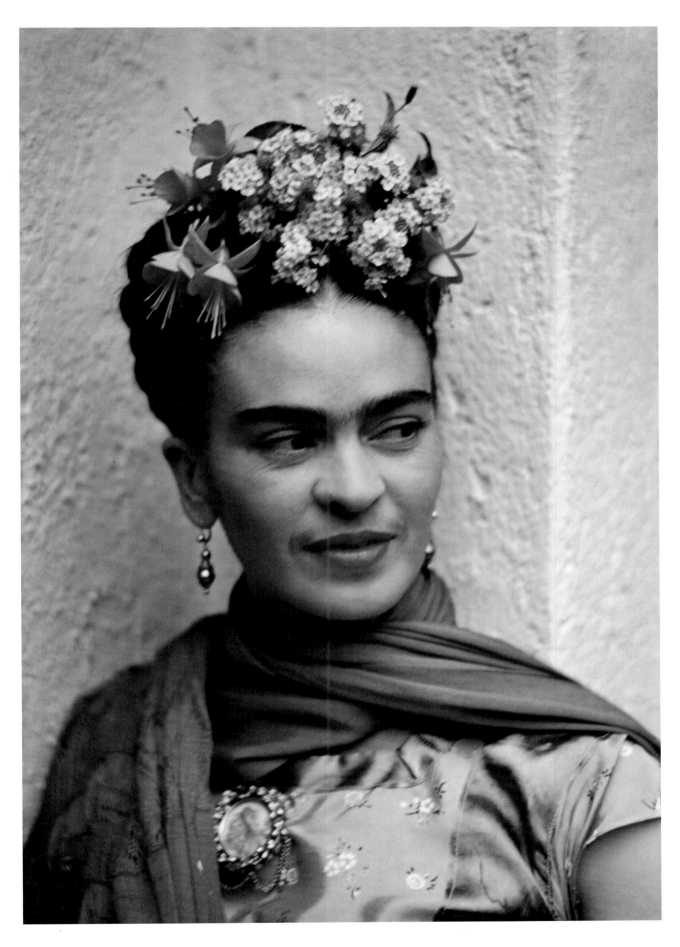

4
Frida, Coyoacán

1938

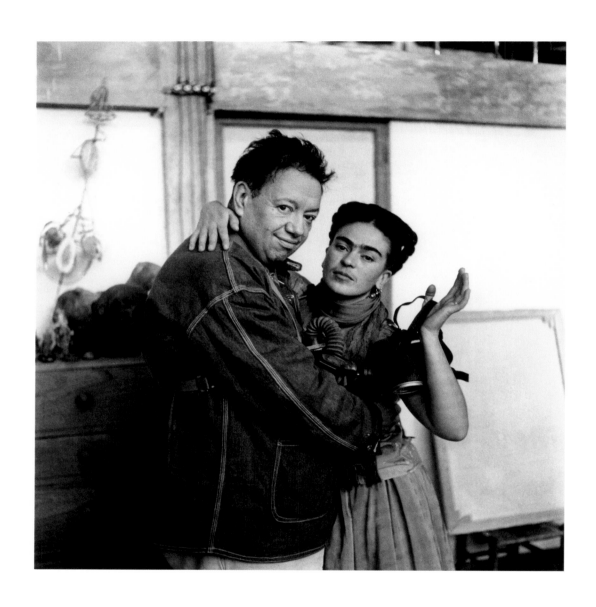

5
Frida and Diego, Coyoacán
1938

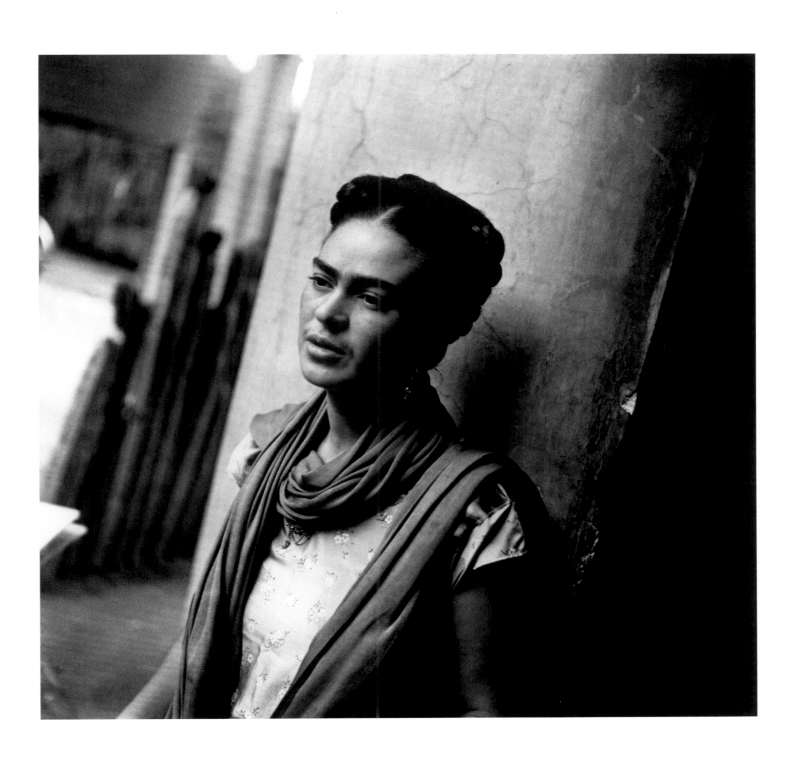

6
Frida, Coyoacán
1938

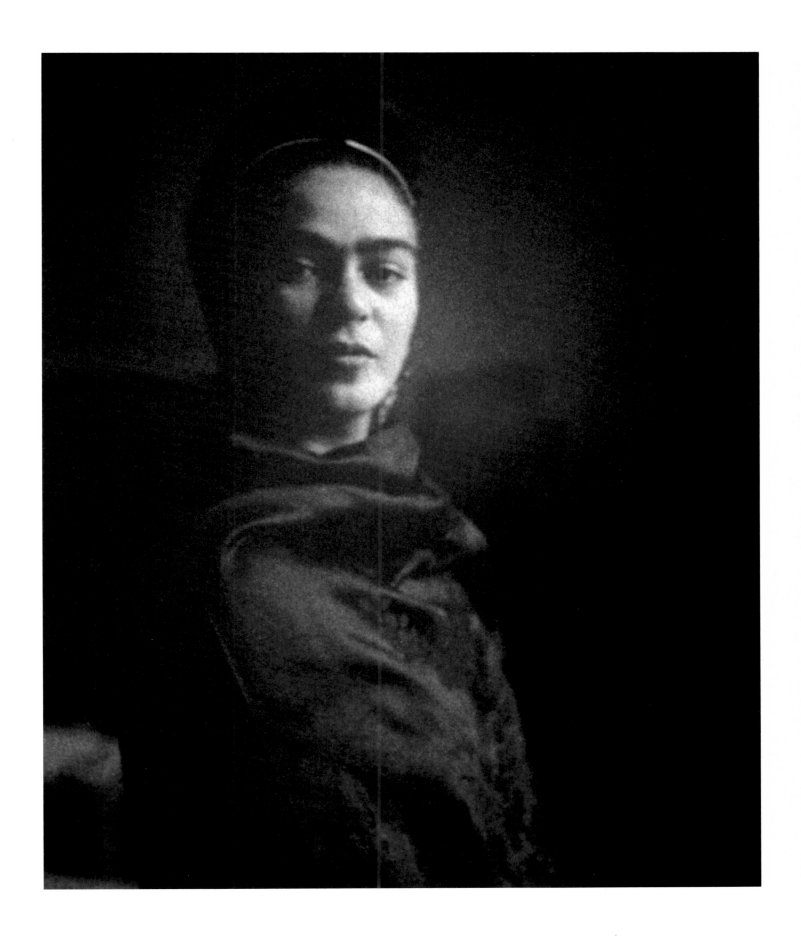

7
Frida, New York
1938

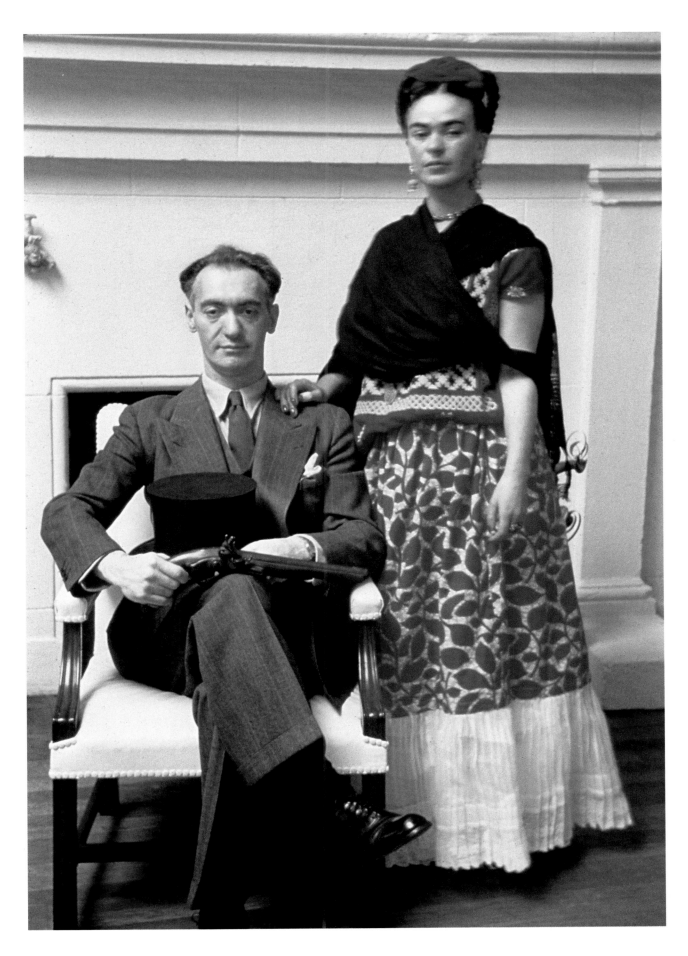

8
Frida with Nick, Barbizon Plaza Hotel, New York
1938

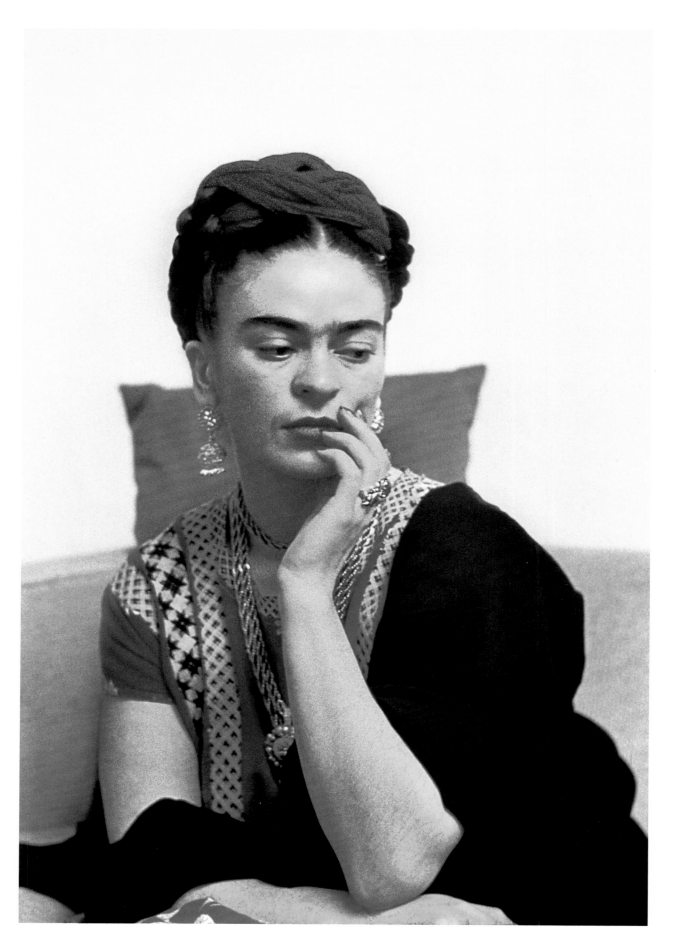

9
Frida, New York
1938

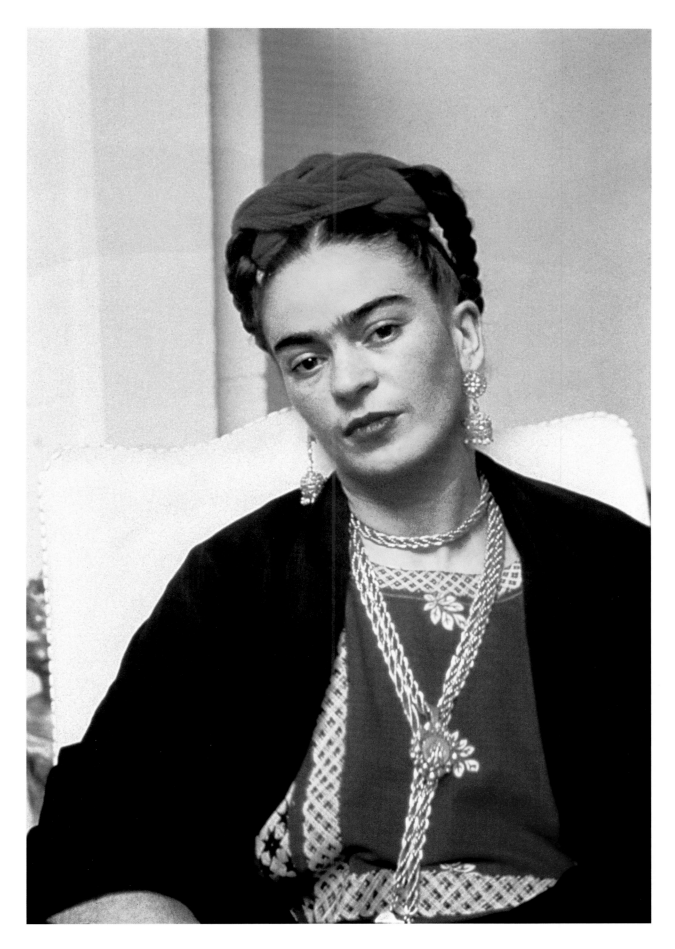

10
Frida, New York
1938

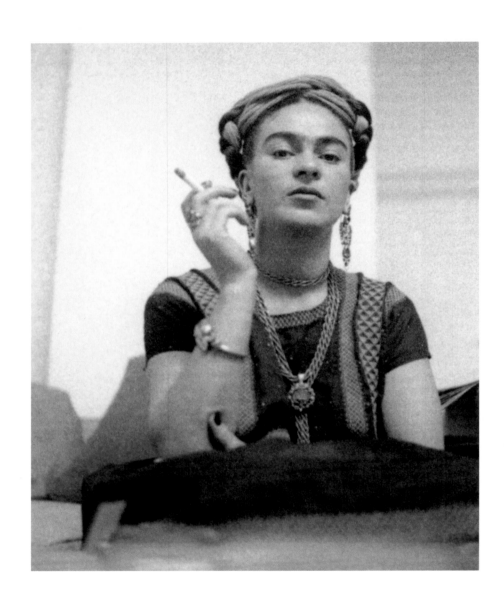

11
Frida, New York
1938

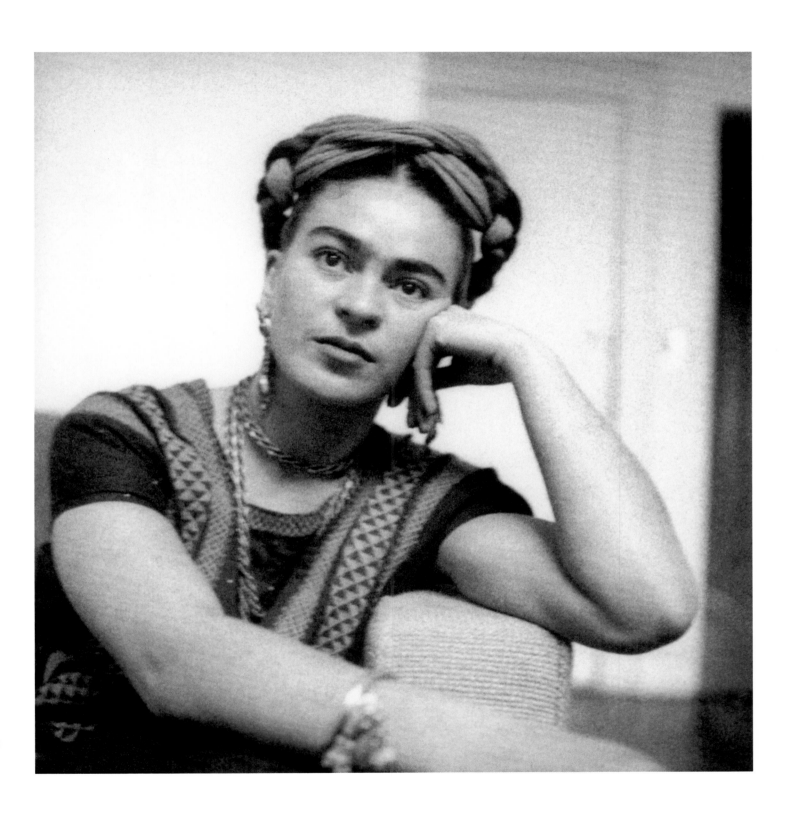

12
Frida, New York
1938

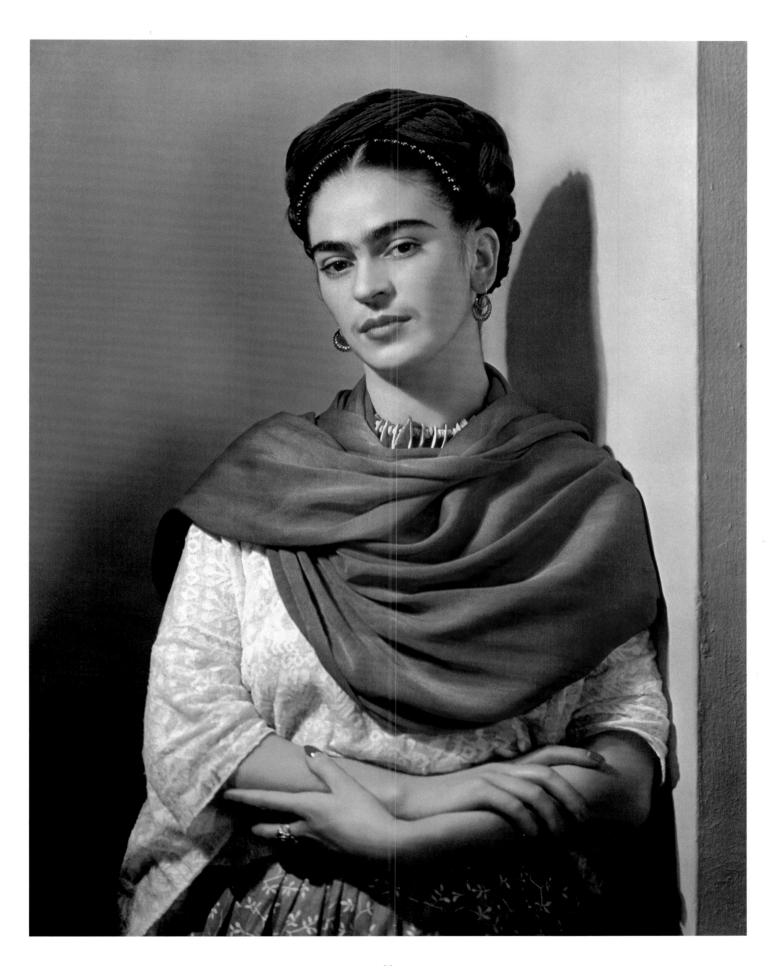

13
Frida with Magenta *Rebozo*, New York
1939

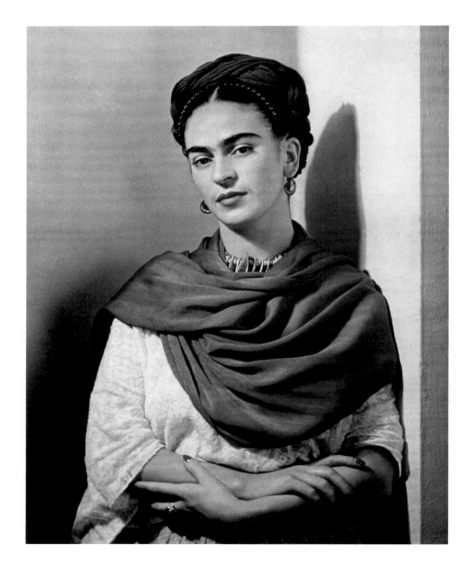

14
Frida with Magenta *Rebozo*, New York
1939

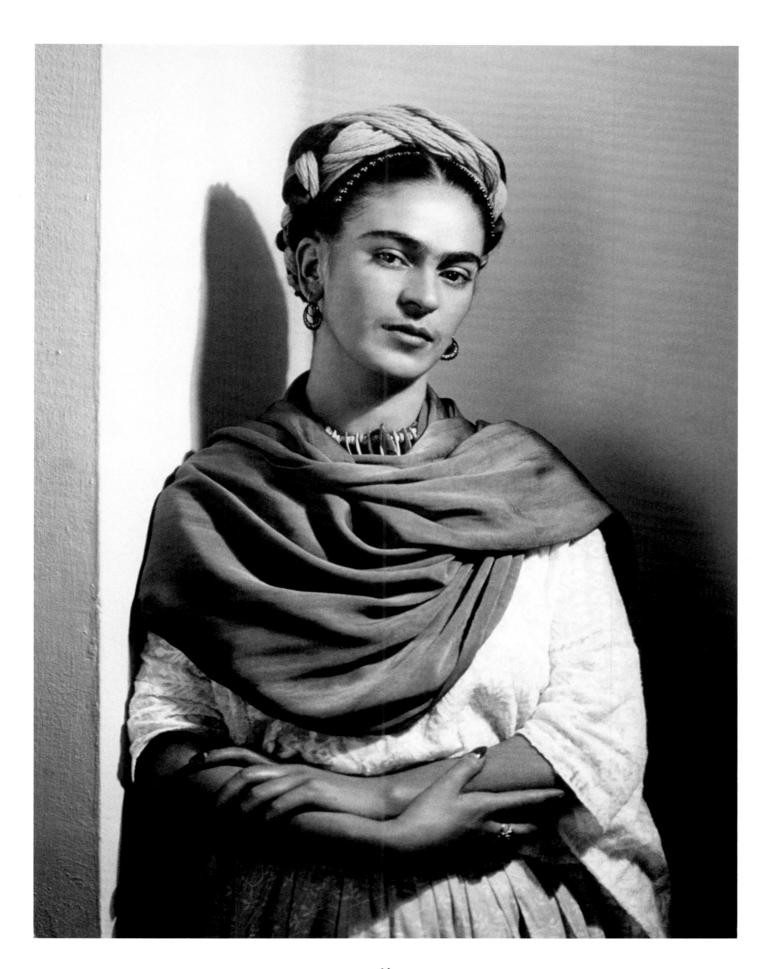

15
Frida with Magenta *Rebozo*, New York
1939

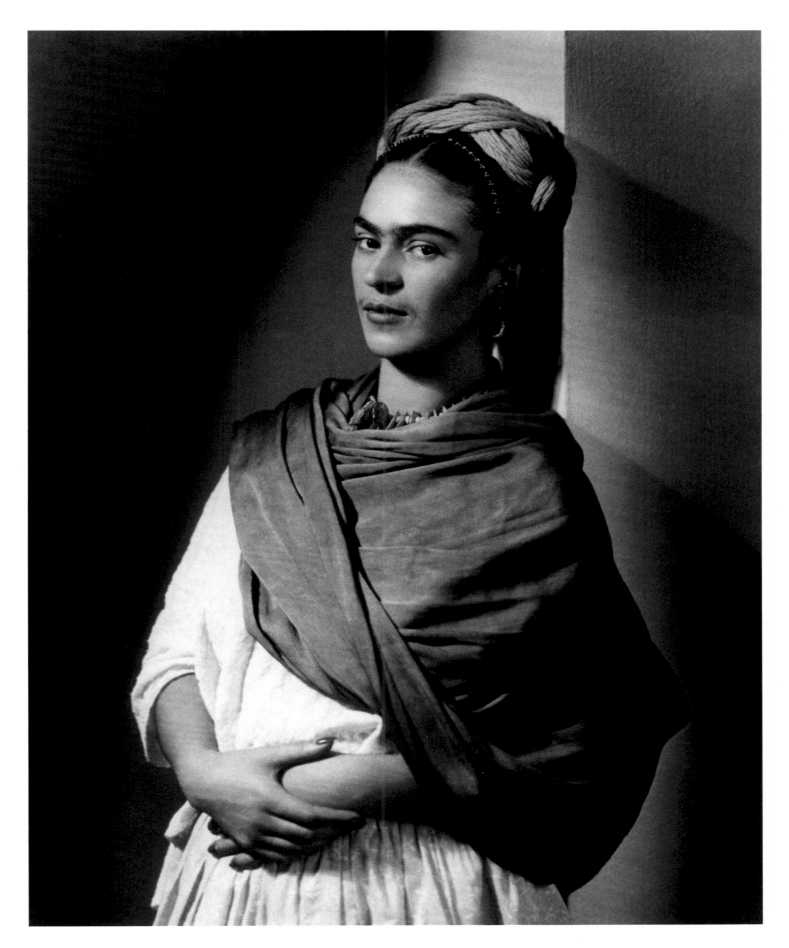

16
Frida with Magenta *Rebozo*, New York

1939

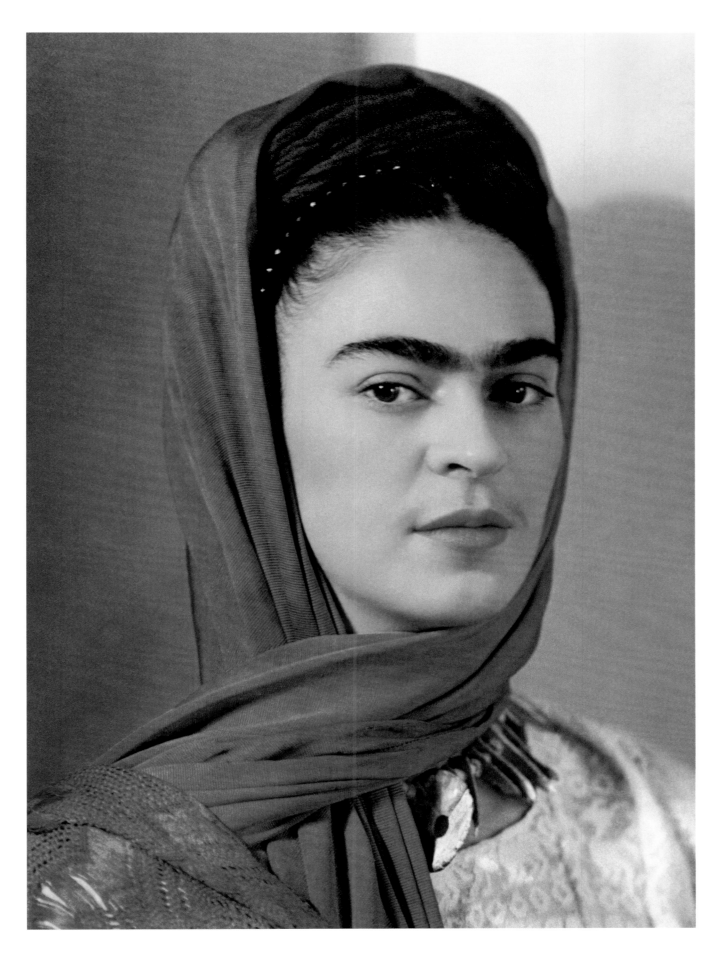

17
Frida with Magenta *Rebozo*, New York
1939

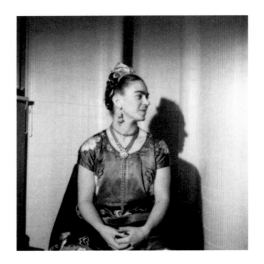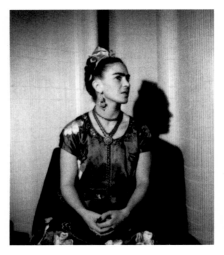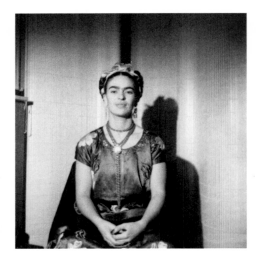

18 — 20
Frida with Blue Satin Blouse, New York
1939

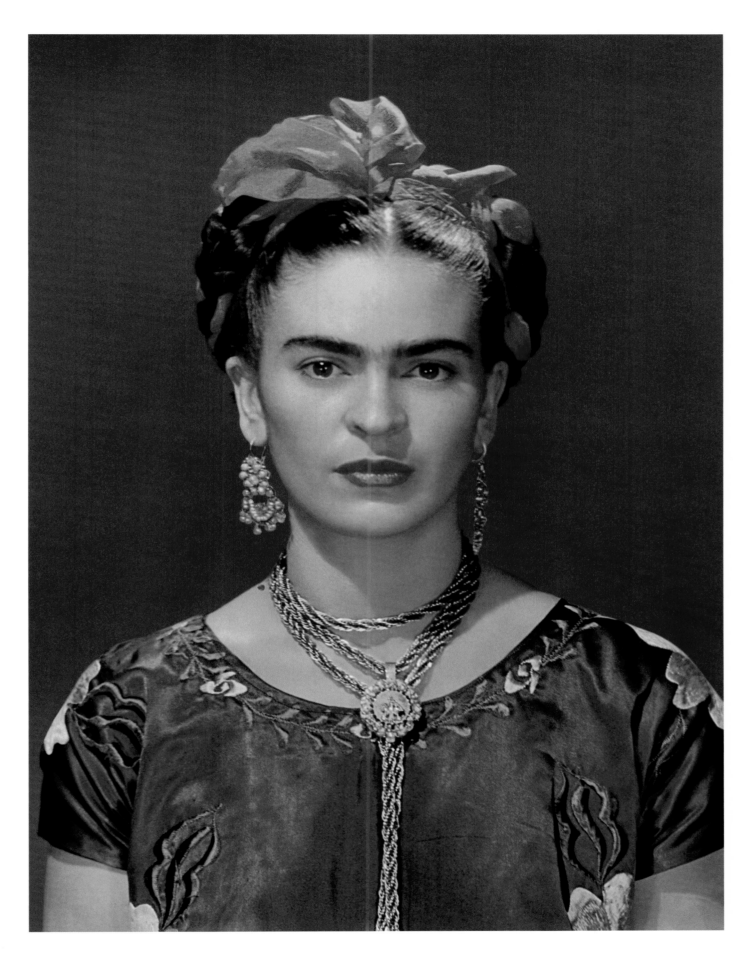

21
Frida with Blue Satin Blouse, New York

1939

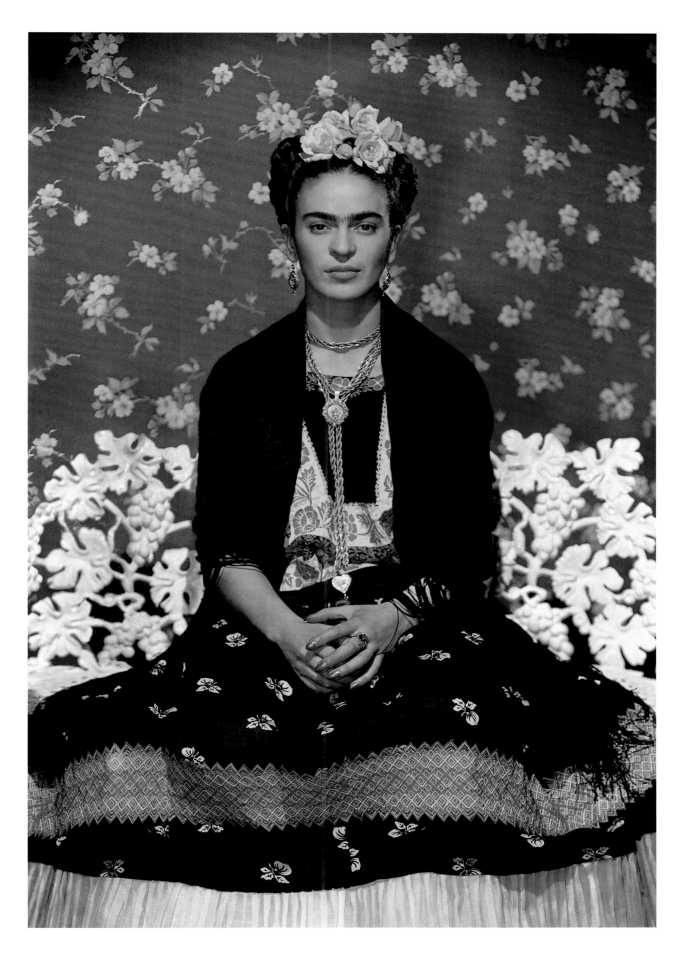

22

Frida on White Bench, New York

1939

23
Frida, Coyoacán

1939

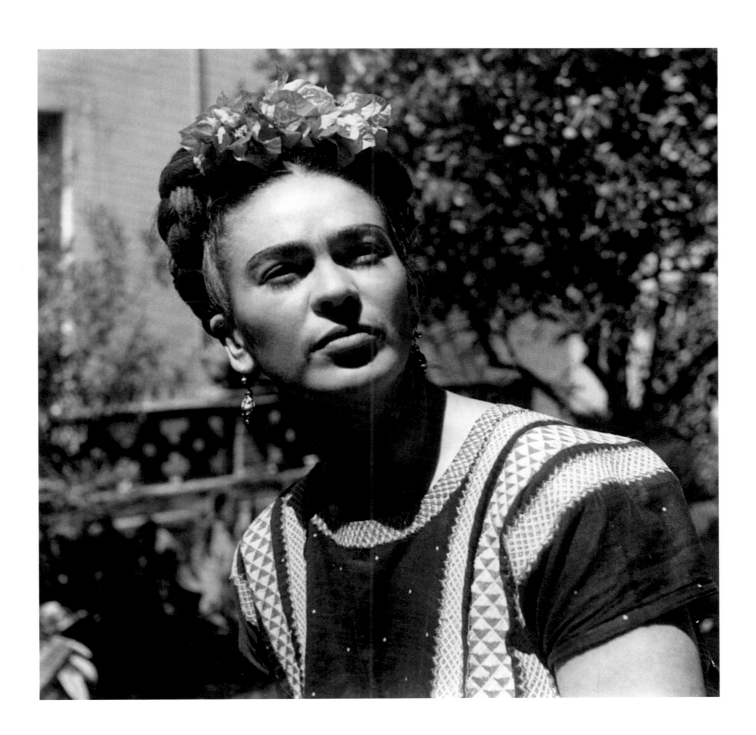

24
Frida, Coyoacán
1939

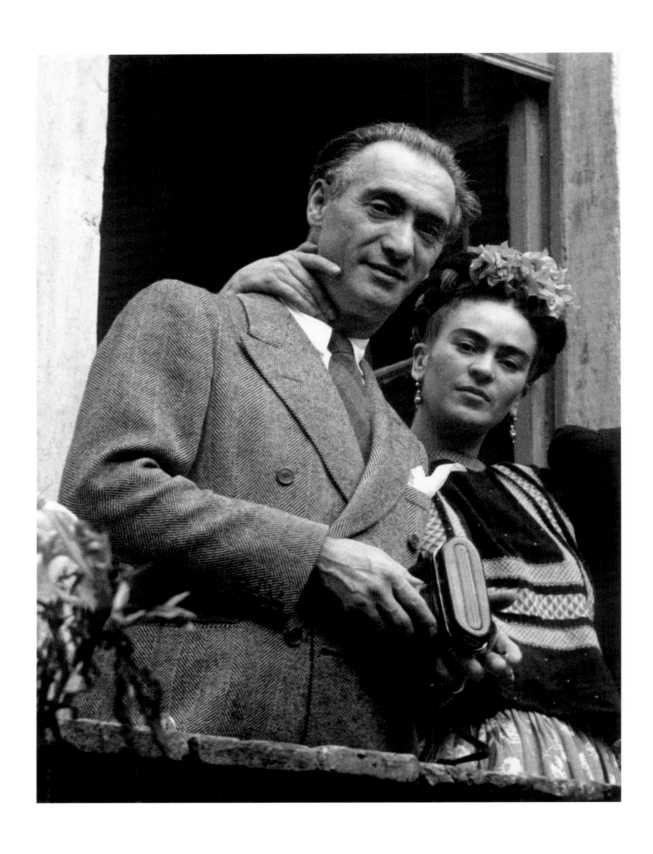

25
Frida with Nick, Coyoacán (detail)
1939

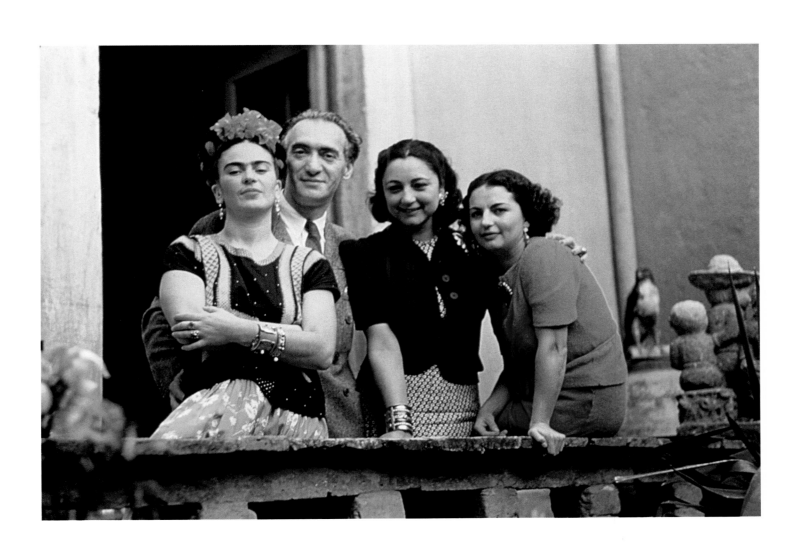

26
Frida, Nick, Rosa Covarrubias, Cristina Kahlo, Coyoacán
1939

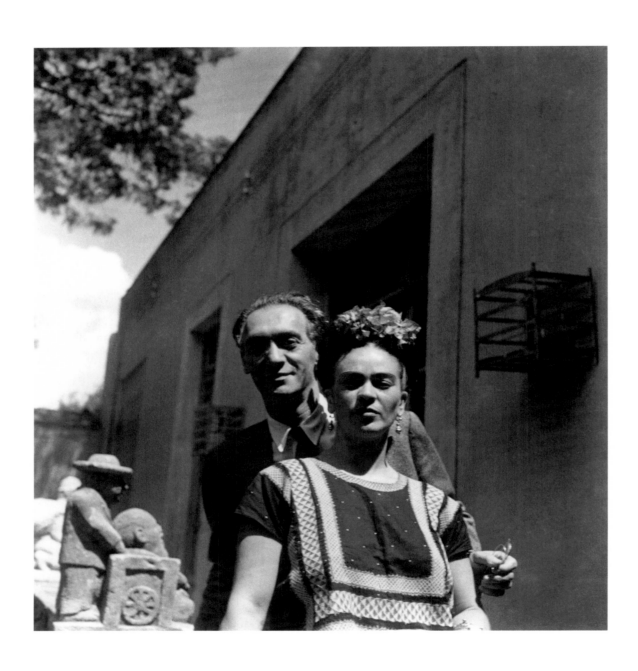

27
Nick and Frida, Coyoacán
1939

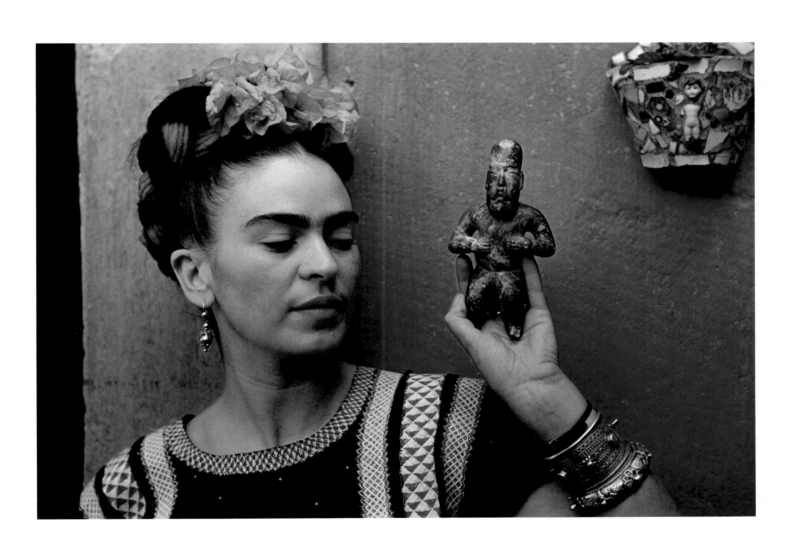

28
Frida with Olmeca figurine, Coyoacán
1939

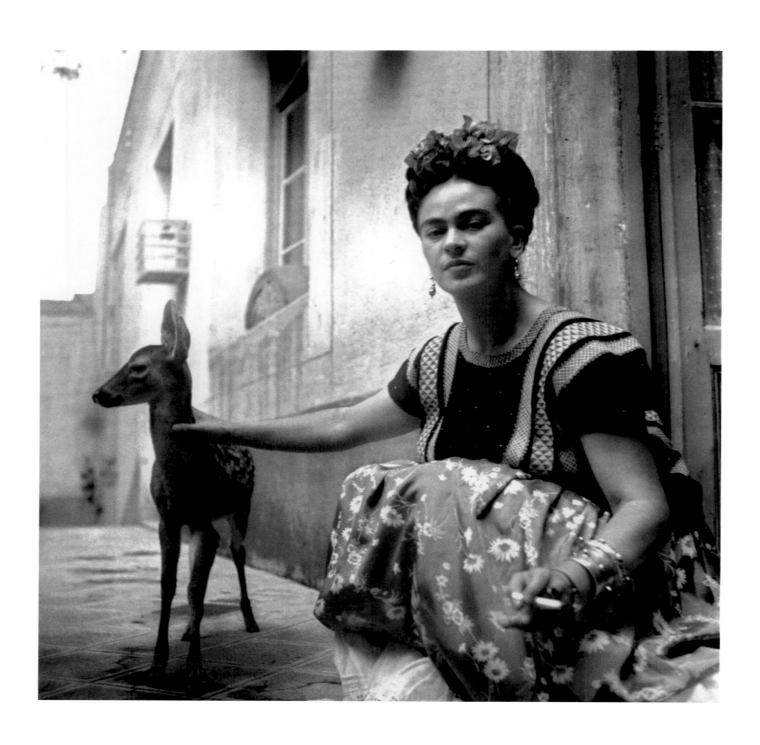

29
Frida with Granizo, Coyoacán

1939

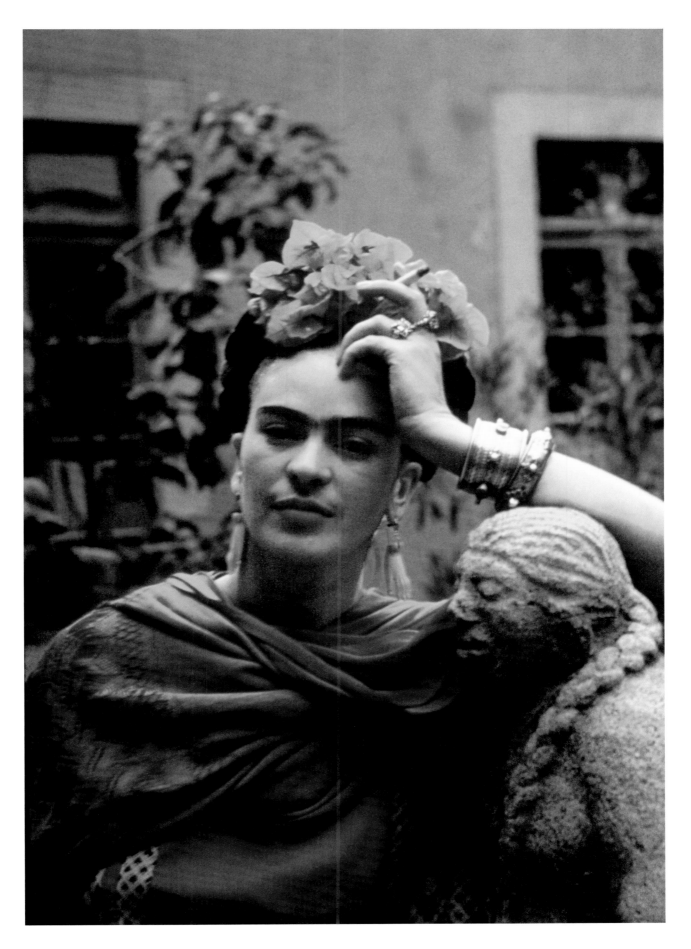

30
Frida leaning on a sculpture by Mardonio Magaña, Coyoacán
1939

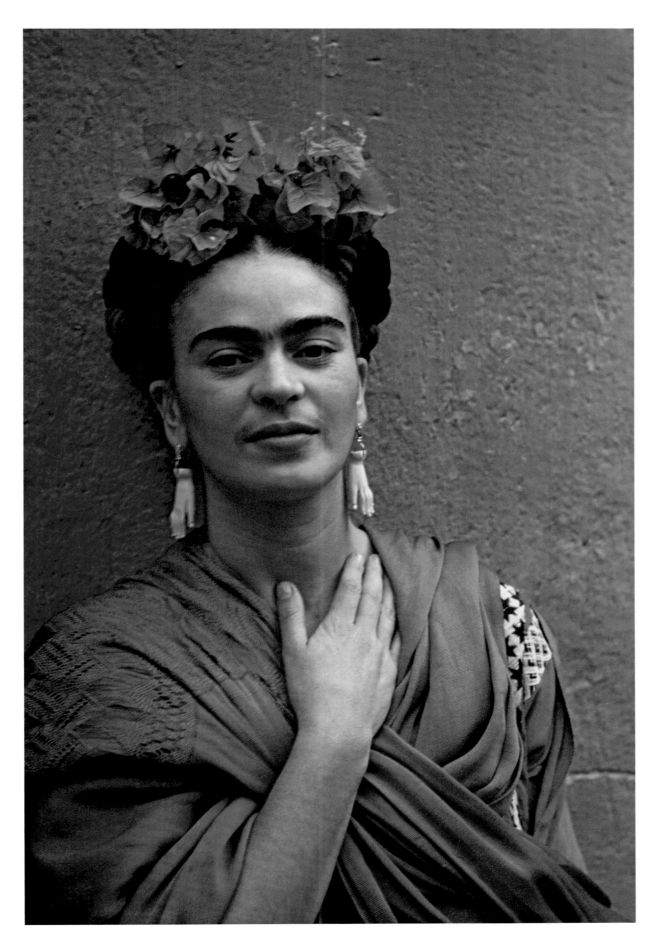

31
Frida, Coyoacán
1939

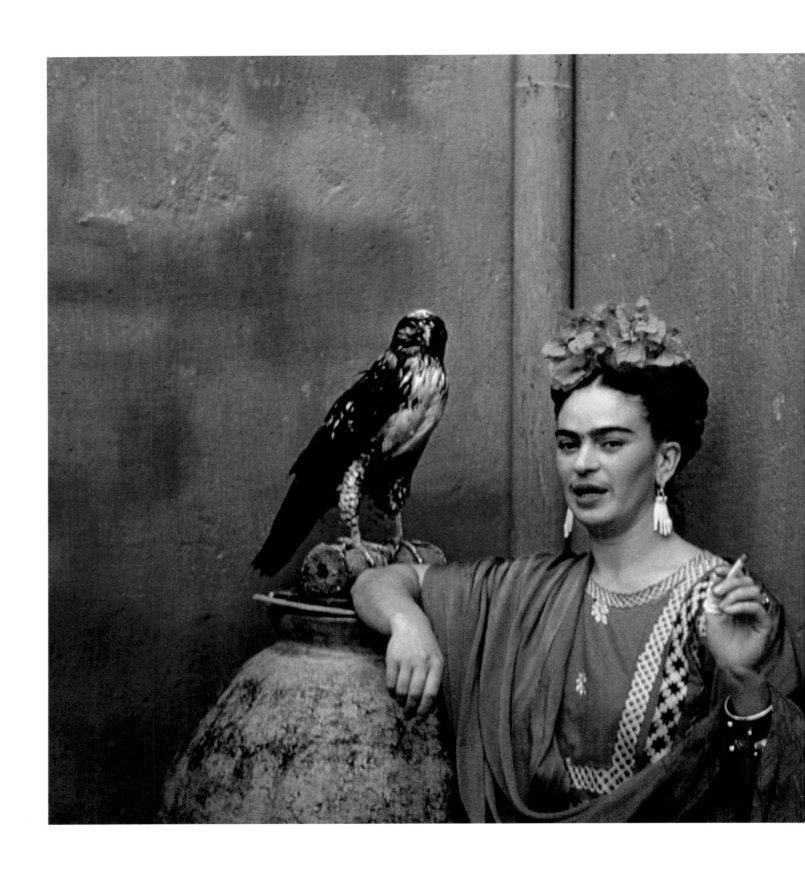

32
Frida with her pet eagle, Coyoacán

1939

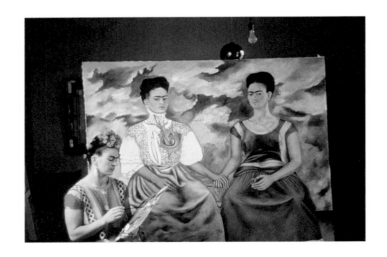
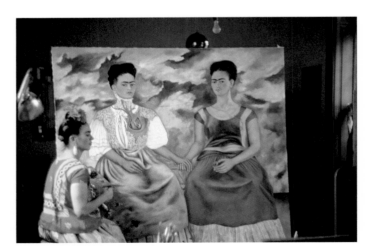

33 — 34
Frida painting *The Two Fridas*, Coyoacán
1939

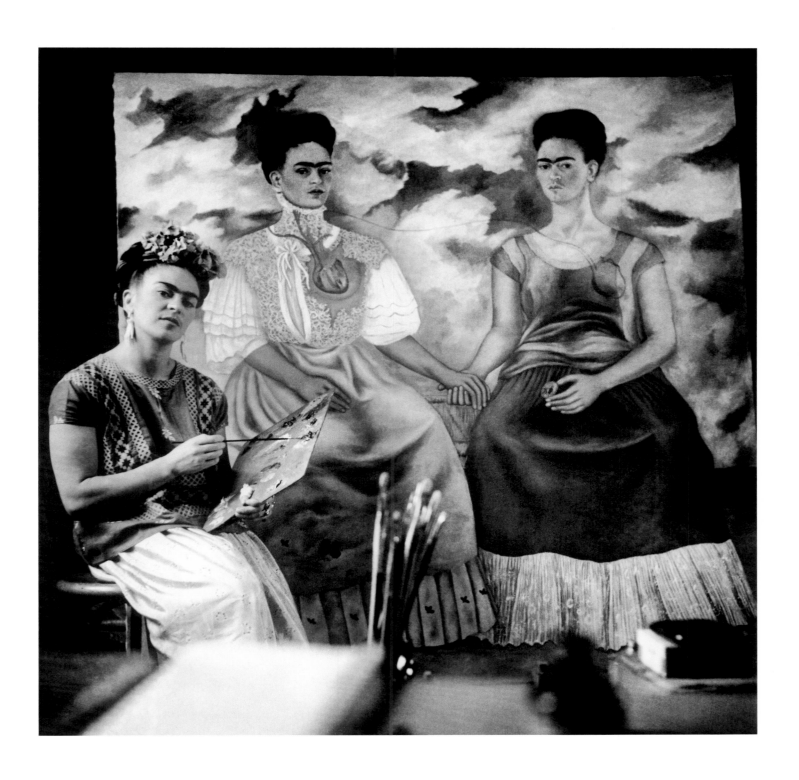

35
Frida painting *The Two Fridas*, Coyoacán
1939

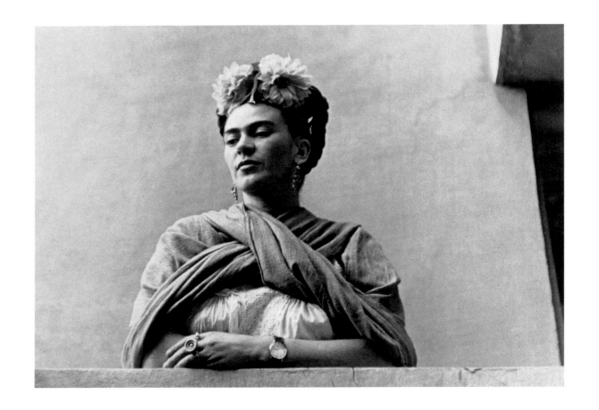

36
Frida, San Angel

1941

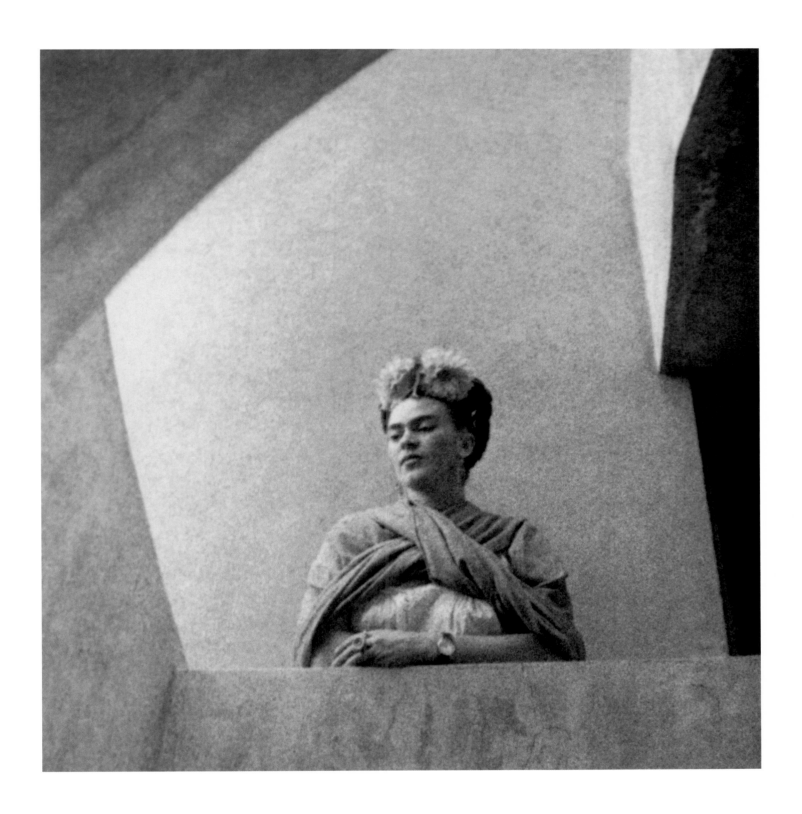

37
Frida, San Angel

1941

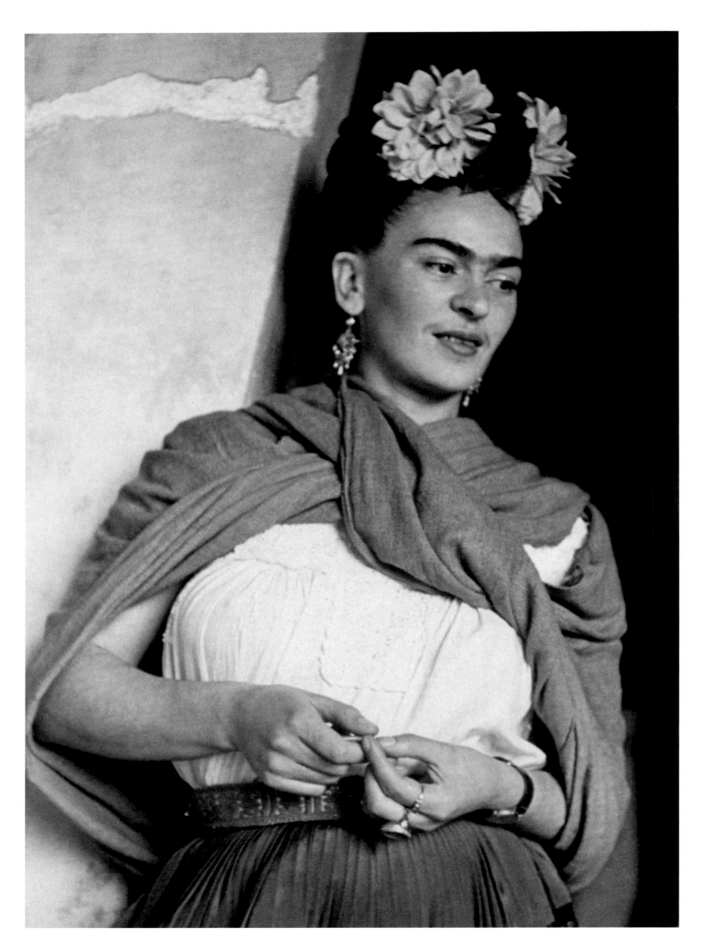

38
Frida, San Angel
1941

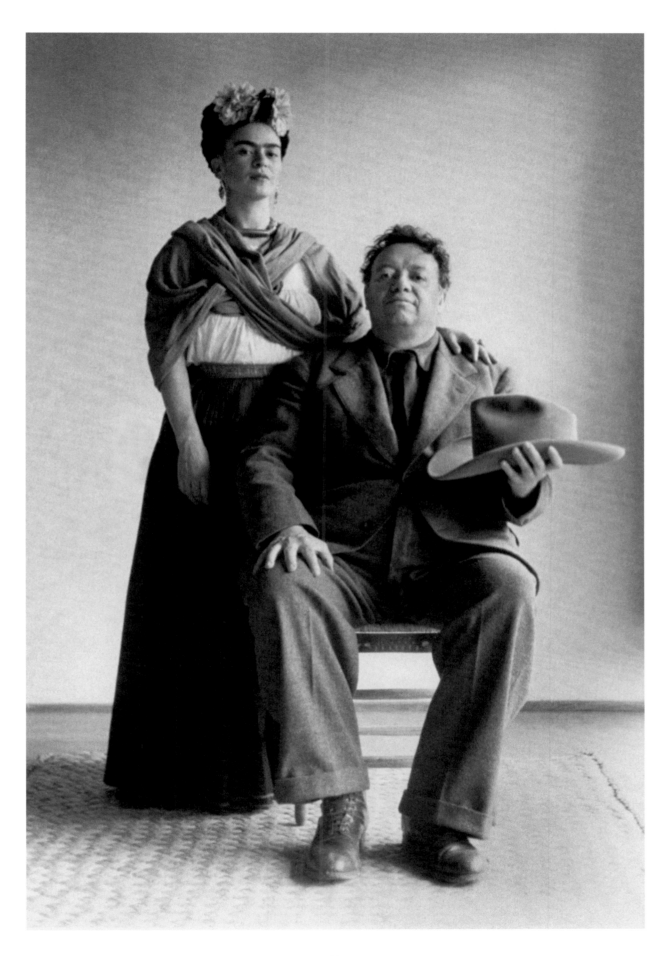

39
Frida with Diego, San Angel
1941

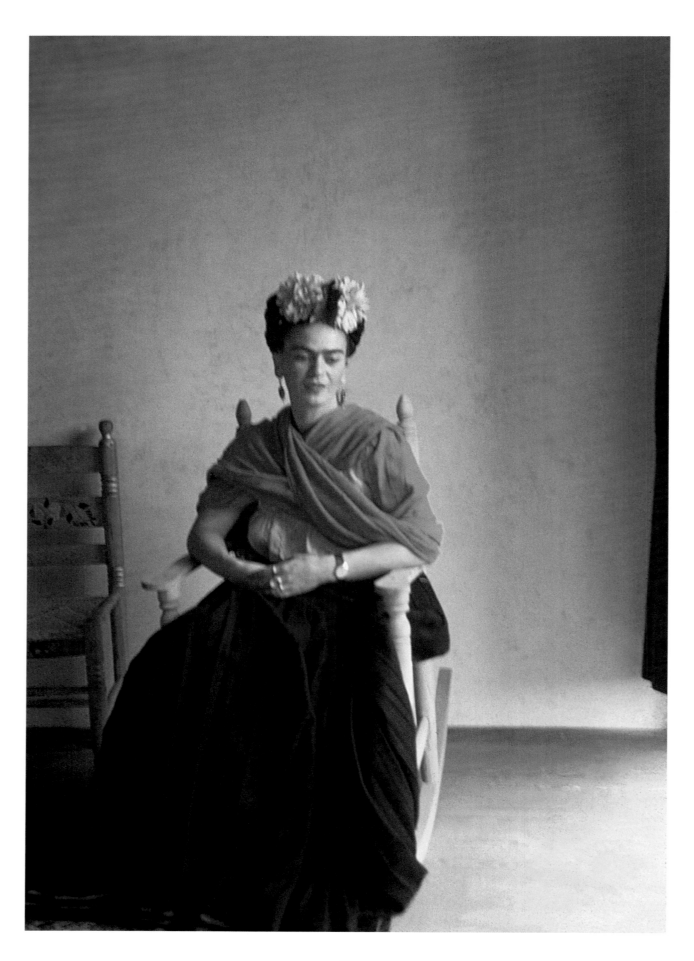

40
Frida, San Angel

1941

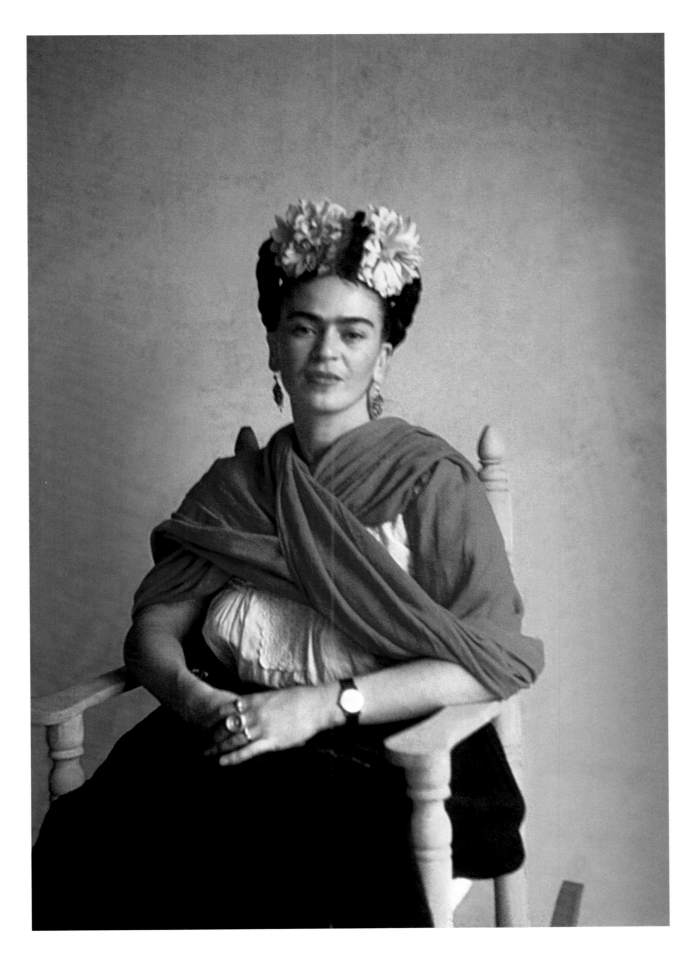

41
Frida, San Angel
1941

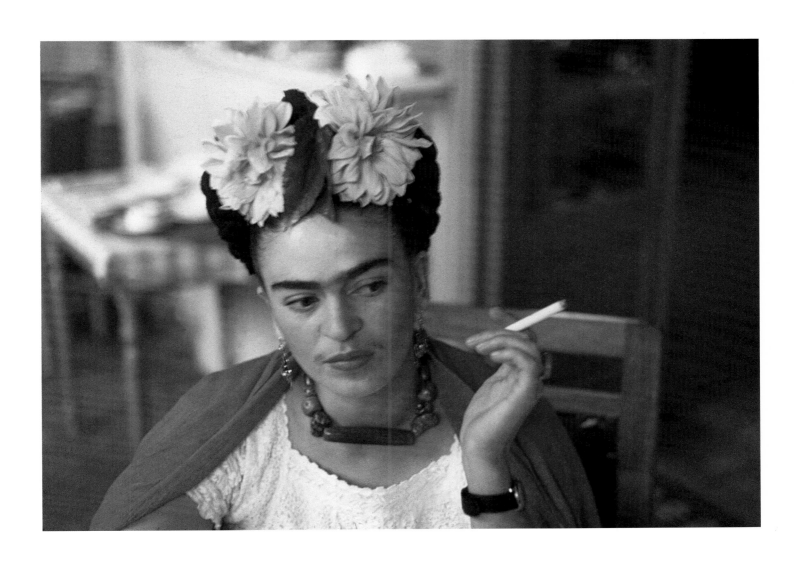

42
Frida in the dining area, Coyoacán
1941

43
Frida with Arija, Coyoacán
1941

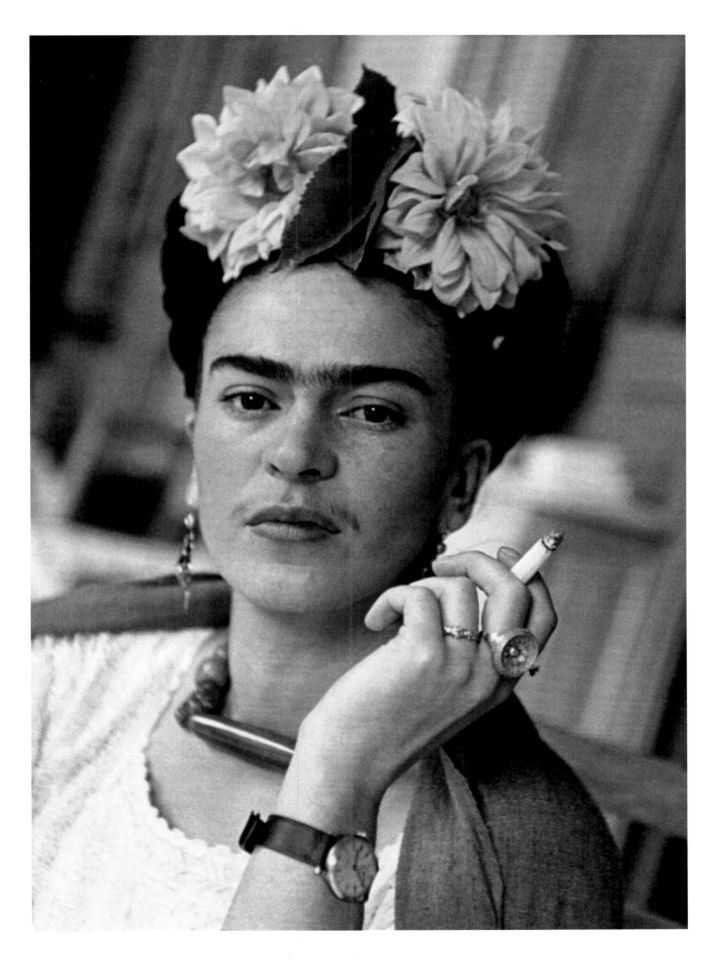

44
Frida in the dining area, Coyoacán
1941

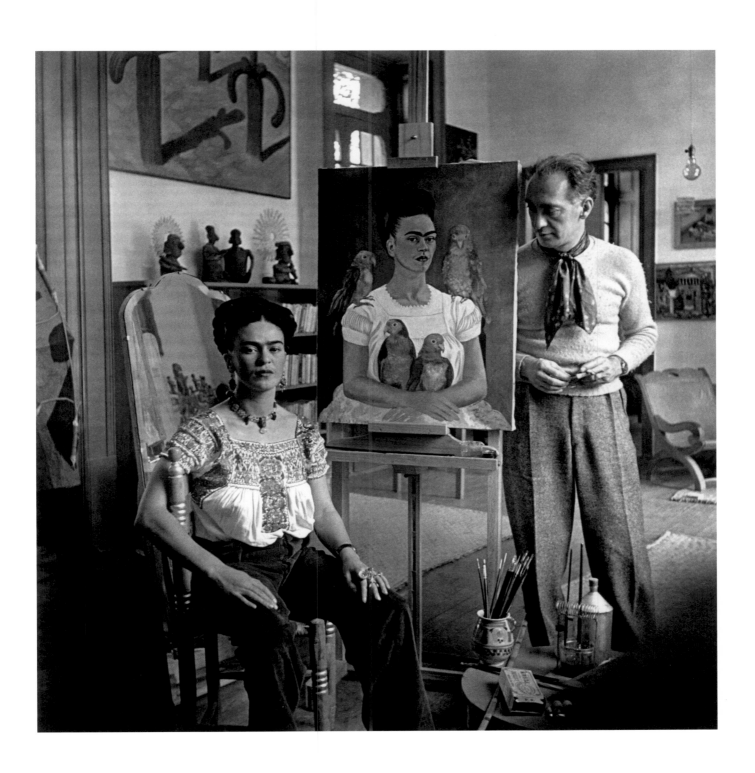

45
Frida with Nick in her studio, Coyoacán
1941

 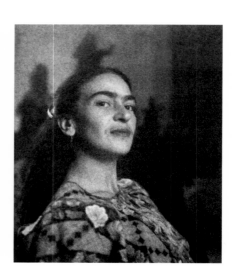

46 – 48
Frida in her wheelchair, Coyoacán

1945

49
Frida in her wheelchair, Coyoacán

1945

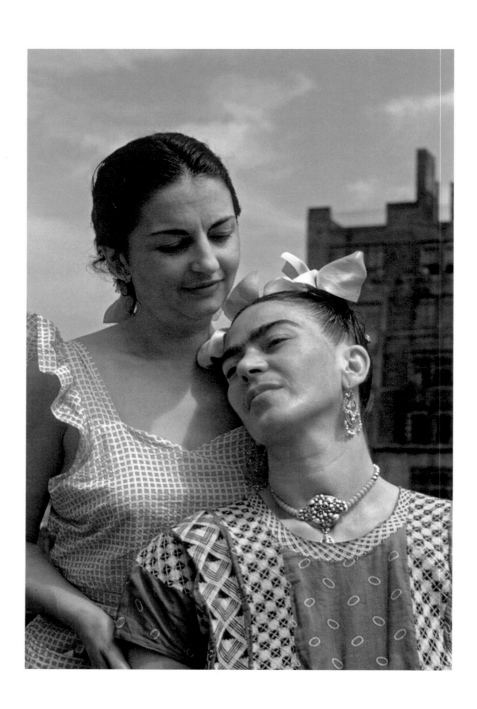

50
Cristina and Frida, New York

1946

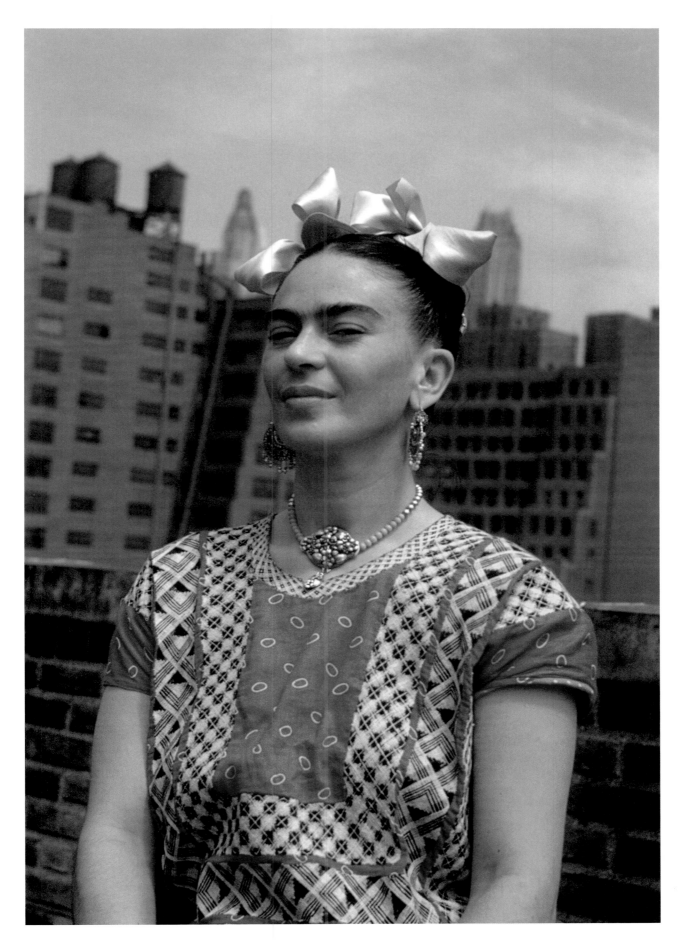

51
Frida, New York

1946

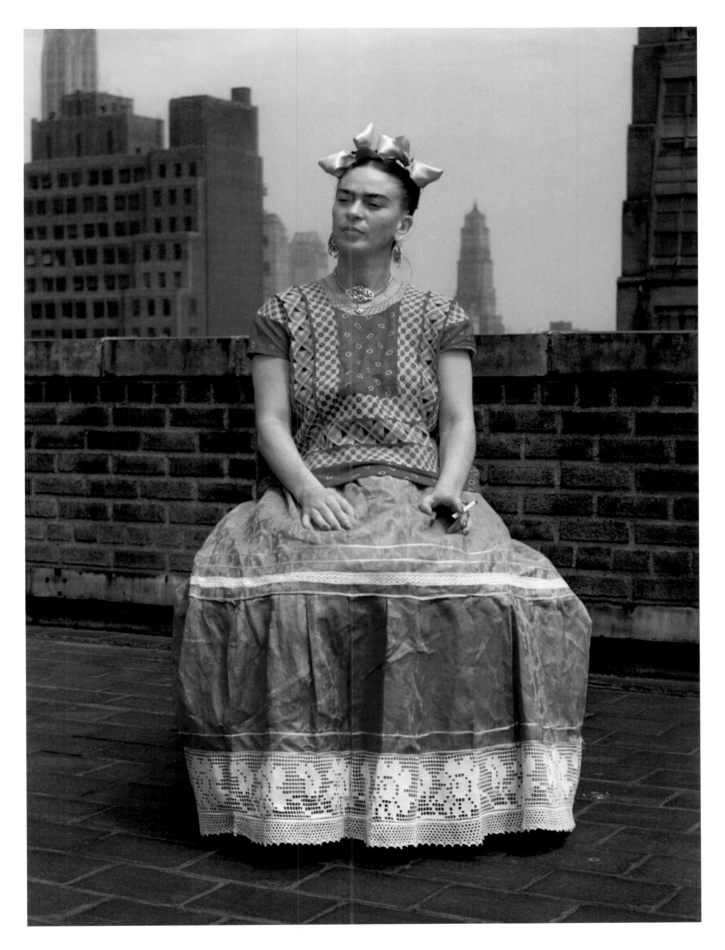

52
Frida, New York
1946

53
Frida in wheelchair, Pedregal
1948

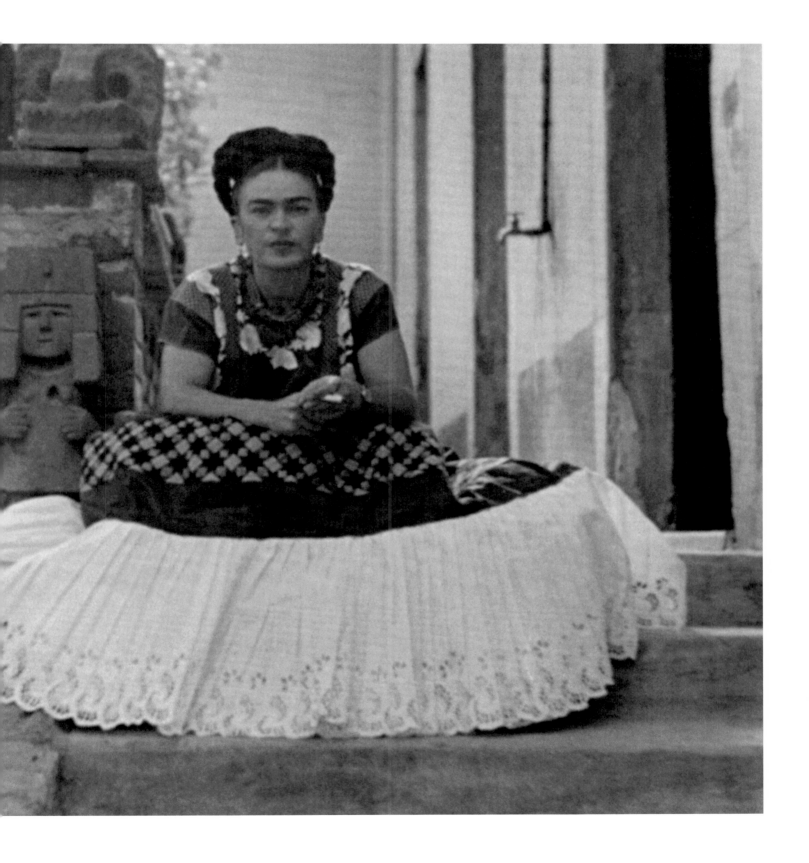

54
Frida, Coyoacán
1948

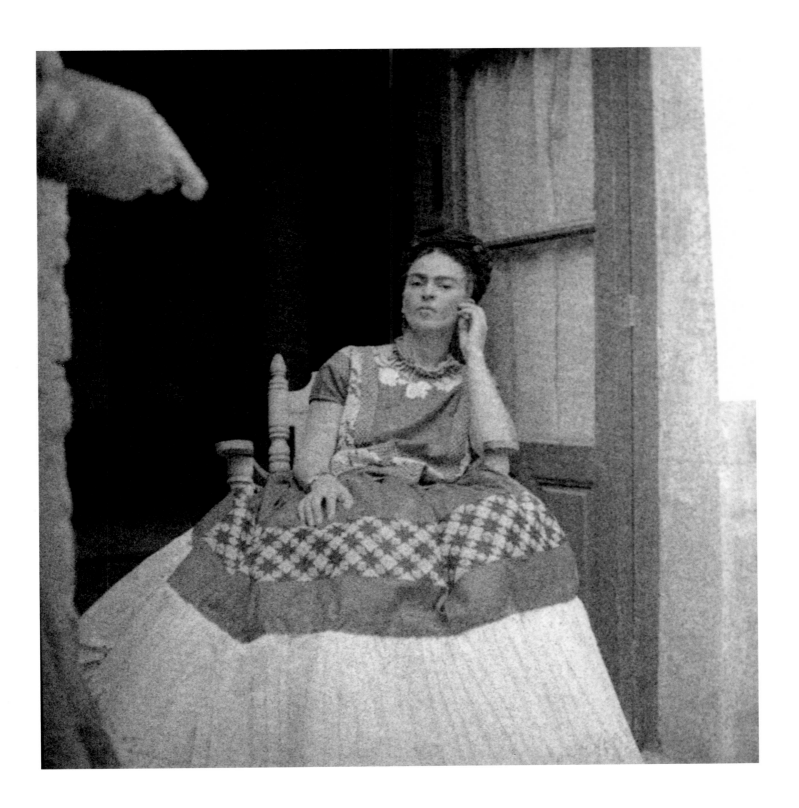

55
Frida sitting outside her bedroom, Coyoacán
1948

Chronology of Nickolas Muray

1892 Born Miklós Mandl on February 15, the fourth of five children: Artur, Vilmos, Margit, Miklós, and Stefan. Father, Samu Mandl, is a postal worker. Mother, Klára Lövit, works at home.
Although his birth date appears in the Book of Birth Registration of the Jewish Community of Zseged, Hungary, he does not receive a Jewish name.
The family, through the Ministry of Home Affairs, changes its surname to Murai, a non-Jewish name.

1894 Family moves to Budapest to improve their academic and economic situation.

1904-8 At twelve, he begins apprenticeship in an artist's studio. There, he learns wood engraving and sculpture. He enters the Budapest Graphic Arts School and studies fundamentals of photography, photoengraving, and lithography. Upon graduation, he signs up with photoengravers Weinwurm & Co. where, for one year, he works as a journeyman engraver doing lithographic reproduction.

1909-13 Studies color separation in Munich for one year. Moves to Berlin where he studies photochemistry, color photoengraving and color filter making at the National Technical School. Earns *International Engravers Certificate* and is hired by Ullstein to do photogravure. He travels in France and England and takes his first photographs, influenced by 17th-century Dutch painting.

1913-16 He arrives in New York in August.
Through the International Photoengravers Union, he immediately finds work doing engraving and color separation for Stockinger in Greenpoint, Brooklyn.

1916-21 Marries Hungarian poet Ilona Fulop.
For Condé Nast Publications in New York, he works as color technician and engraver, doing color separation negatives for *Vanity Fair*. Lives in a shared studio on Washington Square and takes photographs for himself, influenced by Steichen with whom he establishes a life-long friendship.

1918-20 In August, he becomes an American citizen, moves to Chicago and works as a Union Operator doing half tone printing and color photoengraving. There, he also begins fencing at the German Turnverein and wins his first competition the following year.

1919 Befriends Eugene O'Neill.

1920-29 Returns to New York and shows his photographs to fashionable portrait photographer Pirie MacDonald, who encourages him to open his own studio. In Greenwich Village, on 129 MacDougal Street, he earns a reputation for his photographic portraits of celebrities in the artistic, literary, musical, theatrical and political world. During the decade, he makes over ten thousand portraits and influences the evolving style of glamour portraiture. Many of the personalities he photographs attend regularly the Wednesday night parties in his Studio. He also does advertising, fashion, interiors, illustrations, and commercial photography on a freelance basis.
Joins the New York Athletic Club studying under Julio Castello and George Santelli; the Washington Square Fencing Club; the Fencers Club and eventually Salle Santelli. At different times, he will represent each with saber, epée, and foil.

1921 Marries Czechoslovakian ballet dancer Leja Gorska.
The publication of his photograph of Florence Reed in *Harper's Bazaar* begins a continuous string of commissions.
Edward Bernays, public relations manager for Chester Hale, the Fokine Ballet, and Rose Rolando, seeks him out to do their portraits. *Vanity Fair* publishes one portrait of a dancer from the Helen Moeller School of dancing. Overnight he becomes photographer of the Dance. He photographs Fred and Adele Astaire, Leon Barte, Agnes De Mille, Anna Duncan, Martha Graham, Doris Humphrey, Ruth St. Denis, Ted Shawn, and Hubert Stowitts, among many others.

1922 Daughter Arija Muray is born on August 11.
Group show: London, *London Royal Philharmonic Society Show*. He earns First Prize.
Accession of six prints to the Smithsonian Institution, United States National Museum.

1923 Carl Van Vechten introduces him to Miguel Covarrubias through whom he will establish a lifelong connection to Mexico.

1924 Films Eugene O'Neill.

1925 Group shows: London, *British Westminster Photographic Exhibition*. First Prize.
Torino, *Primo Salon Italiano D'Arte Fotografica Internazionale*.

1926 Assigned by *Vanity Fair* to photograph President Calvin Coolidge, Secretary of Commerce Herbert Hoover, and to travel to Europe to photograph Sir Hal Cain, Jean Cocteau, John Galsworthy, Ferenc Molnar, Claude Monet, Miklós Pogany, G.B. Shaw, H.G. Wells. He also photographs Helen Keller.

1926-28 Becomes critic for *Dance Magazine*.

1926-27 He becomes official photographer for the Theater Guild.
Through Covarrubias, he befriends Rufino Tamayo.

1927-28 Wins the National Saber Team Championship both consecutive years.

1928 and 1932 He represents the U.S. Olympic Fencing Team in both years, and in 1932, he comes in fourth place.

1929 Marries Monica O'Shea.
Wins National Saber Championship.
On assignement in Hollywood for *Vanity Fair,* he photographs Douglas Fairbanks and Mary Pickford; Douglas Fairbanks Jr. and Joan Crawford; Greta Garbo; Jean Harlow.

1930-31 Following the stock market crash, he shifts the major focus of his creativity toward advertisement photography. Contract with Curtis Publications, publisher of *Ladies Home Journal,* for which he creates the following year the first color advertisement reproduction in a magazine made from a color carbro: 'Seventeen models in beachwear in Miami.'

1931 With Miguel Covarrubias he makes the first of many trips to Mexico, where he befriends Frida Kahlo.

1934, '40, '42, '50, '51 He earns the Metropolitan Saber Championship.

1935-45 Contract with *McCalls* to do their homemaking covers and food pages.

1935 and 1936 Wins National Foil Team Championship.
Vanity Fair merges with *Vogue* for which he will photograph fashions and portraits of the famous.

1938 Individual show: London, Royal Photographic Society, *Colour Prints by Nickolas Muray*.
Contract with *TIME* to do color covers.

1940-43 Joins the U.S. Civil Air Patrol as Second Lieutenant and discharged as First Lieutenant.
At New York University, Spring Term, he is Director of Courses in Color Photography at photography workshop. Other participants are Leo Aarons, Margaret Bourke-White, Anton Bruehl, Alfred Eisenstaedt, Van Fisher, Ralph Steiner, and Marcel Sternberger.

1941 Arija dies after a short illness, on September 19.

1942 Marries Margaret Schwab on July 23

1943 Daughter Michael Brooke is born on June 7.
Group show: London, *The Color Group of the Royal Photographic Society.*

1945-6 Portraits of Hollywood Stars for M.G.M., Paramount, and for covers of Dell Publications: Ingrid Bergman, Humphrey Bogart, Ava Gardner, Judy Garland, Jean Simmons, Frank Sinatra, Elizabeth Taylor, etc.

1945 Son Nicholas Christopher is born on December 24.

1955 Fencing Director-Judge at the Pan American Games.

1956-57 He becomes Life Member of Art Directors Club.
With a grant from the Wenner-Gren Foundation for

Anthropological Research, he travels as its official photographer for eight months in around-the-world expedition directed by Doctor Paul Fejos.

1956 Fencing Director-Judge at the Olympic Games in Melbourne

1958 Responsible for photographing the *Robert Woods Bliss Collection PRE-COLUMBIAN ART* with text and critical analyses by S. K. Lothrop, W. F. Foshag, and Joy Mahler.

1960 Fencing Director-Judge at the Olympic Games in Rome.
Individual show: Chicago, Chicago Natural History Museum, *Nickolas Muray: Peoples of The World*

1961 On February 9, he suffers a cardiac arrest while fencing at New York's Athletic Club. Fencing partner Dr. Barry Pariser, who performs heart massage, resuscitates him.

1962 Takes partial retirement, closes his studio, and freelances for P. Wing Studio Inc.

1964 He presides as Fencing Director-Judge at the Olympic games in Tokyo.
Individual show: New York, *New York Coliseum's International Photography Fair.*

1965 Individual shows: New York, The Coffee House Club, '*Vanities Fair;*' New York, Gallery of Modern Art, *The Twenties Revisited.*
While fencing at the New York Athletic Club, he dies from a massive heart attack.
At the time of his death, he had won over sixty fencing medals, and was hailed as 'One of the twenty greatest fencers in American History.'

1974 Retrospective: Rochester, New York, International Museum of Photography, George Eastman House *NICKOLAS MURAY.* Exhibition traveled to The Photographers' Gallery, London; and Venice, '79.

1978 Individual show: New York, Prakapas Gallery: *NICKOLAS MURAY.* Washington's National Portrait Gallery acquires several portraits for its permanent collection.
Fencing Hall of Fame admits him as its member.

1979 Group shows: New York, International Center for Photography, *Fleeting Gestures: Dance Photographs*; Zurich, Kunsthaus, *AMERIKA FOTOGRAFIE 1920–1940*

1997 Group show: New York, James Danziger Gallery, *The American Century, Photographs and Visions, Part I: 1900-1935.* The show traveled to Stephen Daiter Photography Gallery, Chicago.

Known Frida Kahlo Photographs
by Nickolas Muray

1937 – Tizapán

Frida

Frida

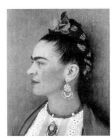

Frida and Diego

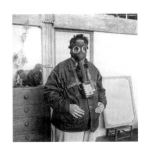

Frida and Diego

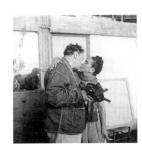

Frida and Diego, and
Miguel Covarrubias

1938 – Countryside

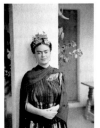

Frida

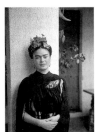

Frida

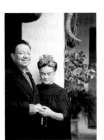

Frida

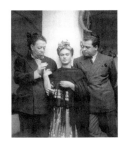

Frida

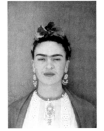

Frida

Frida

1938 – Coyoacán

Frida with picture frame (on
wall *Self-Portrait Remembrance
of an Open Wound*, 1938)

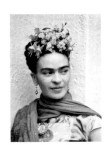

Frida

1938 – San Angel

Frida in front of the cactus
organ fence

Frida in front of the
cactus organ fence

1938 – Coyoacán

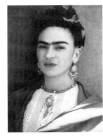

Frida

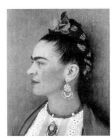

Frida

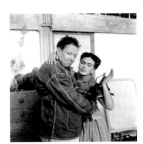

Frida with Diego

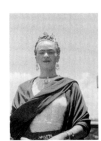

Diego with gas mask

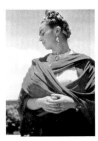

Frida and Diego, kissing

1938 – San Angel

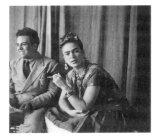

Miguel and Frida

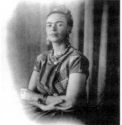

Frida

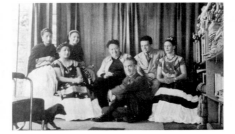

l.t.r.: Alfa Ríos Henestrosa and Beta Ríos Pineda, Rosa Covarrubias, Diego Rivera, Nickolas Muray, Miguel Covarrubias, Frida Kahlo and the itzcuintli dog Kaganaovich

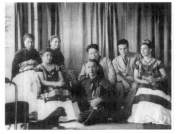

l.t.r.: Alfa Ríos Henestrosa and Beta Ríos Pineda, Rosa Covarrubias, Diego Rivera, Nickolas Muray, Miguel Covarrubias, Frida Kahlo and the itzcuintli dog Kaganaovich

1938 – New York

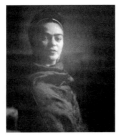

Frida

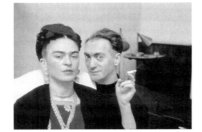

Frida with Nick in Barbizon Plaza Hotel

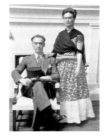

Frida with Nick in Barbizon Plaza Hotel

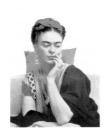

Frida

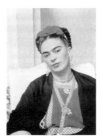

Frida

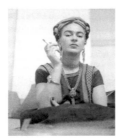

Frida

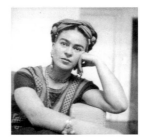

Frida

1939 – New York, in Nickolas Muray's studio

Frida with Magenta *Rebozo* (printed for André Breton)

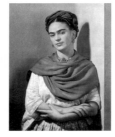

Frida with Magenta *Rebozo* (carbro)

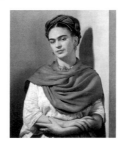

Frida with Magenta *Rebozo* (b/w)

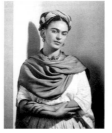

Frida with Magenta *Rebozo* (b/w, printed in reverse)

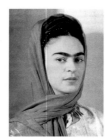

Frida with Magenta *Rebozo* (head covered)

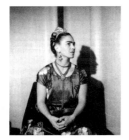

Frida Kahlo with Blue Satin Blouse (trial photo)

Frida Kahlo with Blue Satin Blouse (trial photo)

Frida Kahlo with Blue Satin Blouse (trial photo)

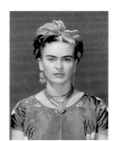

Frida Kahlo with Blue Satin Blouse (final portrait)

1939 – New York, in Nickolas Muray's studio

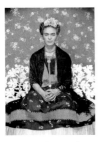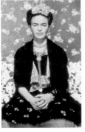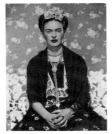

Frida Kahlo on white
Bench (carbro)

Frida Kahlo on white
Bench (version 1)

Frida Kahlo on white
Bench (b/w)

1939 – Coyoacán

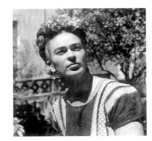

Frida in Coyoacán

Frida

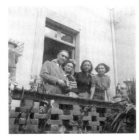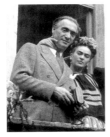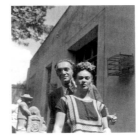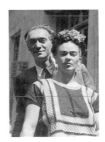

l.t.r.: Nick Muray, Frida Kahlo,
Rosa Covarrubias, Cristina Kahlo

Frida with Hand Touching
Nick's Cheek (detail from
group photo)

Nick and Frida

Nick and Frida
(cropped by Nick)

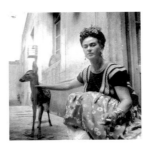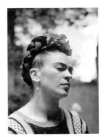

l.t.r.: Frida Kahlo, Nick Muray, Rosa Covarrubias,
Cristina Kahlo

Frida with Olmeca Figurine

Frida

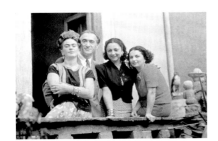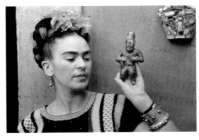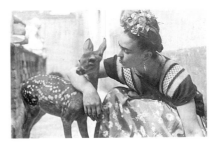

Antonio and Isolda Pinedo with
Cristina Kahlo, their mother

Isolda Pinedo with
Granizo

Frida with Granizo

Frida with Granizo, version 1

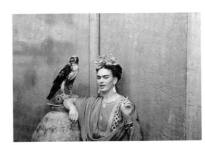

Frida painting *The Two Fridas*

Frida painting *The Two Fridas*

Frida painting *The Two Fridas*
(b/w)

Frida with her pet eagle

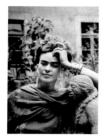

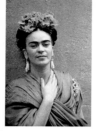

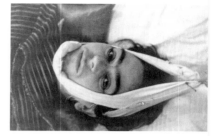

Frida leaning on a sculpture by Mardonio Magaña

Frida with her hand at her throat

Justino Fernández, Rosa Covarrubias, Frida (in bed), Cristina Kahlo in hospital

Frida in traction

1941 – San Angel

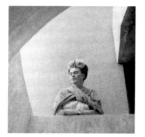

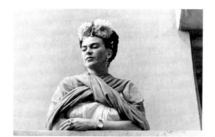

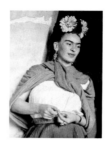

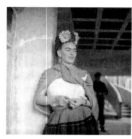

Frida

Frida

Frida

Frida

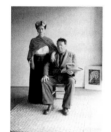

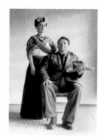

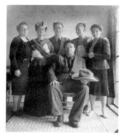

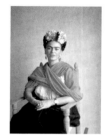

Frida with Diego

Frida with Diego

Diego with Frida

l.t.r.: Ione Robinson, Frida Kahlo, Nick Muray, Diego Rivera (sitting) Emmy Lou Packard, and Arija Muray

Frida

Frida

1941 – Coyoacán

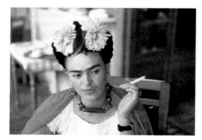

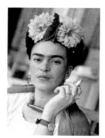

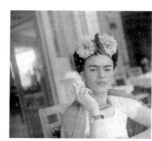

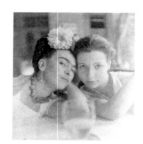

Frida in the dining area

Frida in the dining area

Frida in the dining area

Frida with Arija

c. **1945** – Coyoacán

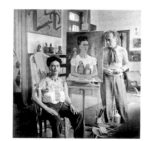

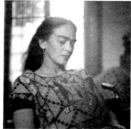

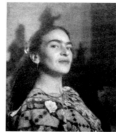

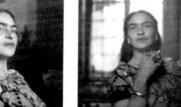

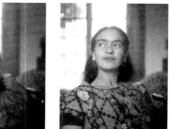

Self-Portrait with Frida Kahlo in her studio and on her easel her Self-Portrait *Me and My Parrots*, 1941

Frida in her wheelchair (series)

116

1946 – New York

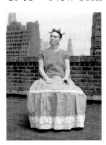

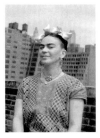

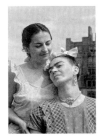

1948 – Coyoacán

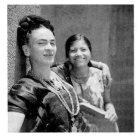

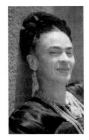

Frida on the rooftop of
Nick Muray's duplex

Frida on the rooftop of
Nick Muray's duplex

Cristina and Frida

Frida and unidentified
companion

Frida (detail from
Frida and unidentified
companion)

1948 – Pedregal

1948 – Coyoacán

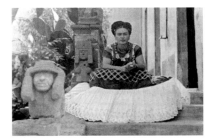

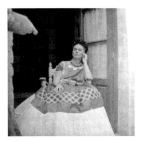

Frida Kahlo in wheelchair
with Helen and Juan
O'Gorman outside of
O'Gorman's surrealist
house in construction

Frida sitting to one side of a
sculpture by Mardonio Magaña

Frida sitting outside her
bedroom

This edition first published 2005 by order of the Tate Trustees
by Tate Publishing, a division of Tate Enterprises Ltd,
Millbank, London SW1P 4RG
www.tate.org.uk/publishing

© Schirmer/Mosel 2004
All works by Frida Kahlo are reproduced
with permission of the Diego Rivera and Frida Kahlo Estate,
Banco Nacional de México
Photographs by Nickolas Muray
© Nickolas Muray Photo Archives, LLC 2004
Text by Salomon Grimberg
© Salomon Grimberg 2004

Authorized English-language edition (UK)
© Tate 2005

British Library Cataloguing in Publication Data
A catalogue record for this book is available
from the British Library

ISBN 1-85437-616-0

A Schirmer/Mosel Production
Design: Klaus E. Göltz, Halle (Germany)
Lithography, printing and binding: EBS Verona (Italy)